Art as Urban

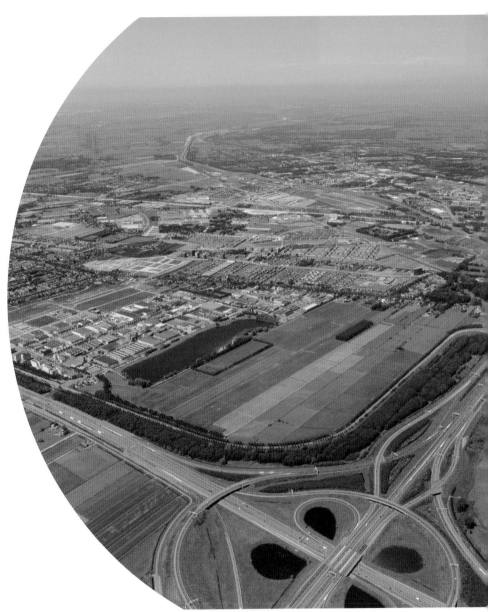

Aerial photograph 2005, photo Gerry Hurkmans, source: Leidsche Rijn Project

Art as Urban Strategy

Beyond Leidsche Rijn

Tom van Gestel
Henriëtte Heezen
Nathalie Zonnenberg
(eds.)

NAi Publishers

FOND FAREWELL

The time has come. Ten years have gone by since that first meeting in the office of Nico Jansen, head of cultural affairs for Utrecht city council. On the table lay a report from the Visual Arts Advisory Committee entitled *A Snowball Worth 10 Million* (guilders not euros). The report argued for a special arts programme for the Vinex area of Leidsche Rijn, the large urban extension to the city of Utrecht. Here everything had to be different than usual.

David Hammons, who sold snowballs on Cooper Square, New York (*Blizzard Ball Sale*, 1983) represented this fresh approach, which was also to be acted upon in the same spirit. Transience instead of permanence was the credo.

The relaunch of the Praktijkbureau Beeldende Kunstopdrachten, an art commissioning agency, in the form of the present SKOR had only just taken place and this project was the first major undertaking of the newly set up foundation. It led to the start of a formidable collaboration between SKOR and Utrecht city council.

In the mass of paperwork that has been produced since then, no record can be found of that first meeting, nor of the first meeting of the since formed Artistic Team, chaired by Peter Kuenzli. Aside from inherent reasons for choosing this enthusiastic chairperson, there were also strategic ones. As former director of the Leidsche Rijn Project Agency, responsible for choosing urban developers, planners, architects and landscape designers, he would give the later Beyond plan status and clout, thereby making it possible to write out and realize a special programme for this.

That first team, which also included Jan van Grunsven, Bernard Colenbrander, Govert Grosfeld and myself, preoccupied itself with drawing up and thinking of a name for a plan. From the council's

side, Mariette Dölle acted as liaison officer and played a crucial role as coordinator.

In the book *S,M,L,XL* by architect Rem Koolhaas, we read, 'For each project there is a beyond, a domain where no jury will follow', a statement that powerfully summed up what we had in mind. The project now had a name: Beyond.

After the discussions, comments, assessment by the advisory committee and acceptance by the local council, we could now begin. Peter Kuenzli had done his job, and I took over from him. But how does a team stick to its remit? Where can there be leeway? Where is the boundary line? How do you communicate with an area that still isn't a community? These and other questions occupied us considerably.

A key question, for instance, was whether Beyond should concern itself with everything to do with visual art, including the per cent rule for this new area, whereby a percentage allocation of new building construction is for art embellishment. No, was the answer. Not because we didn't consider the rule important, but because the commissions resulting from this were outside the scope of the plan. Through an art programme, we were obligated to focus on promoting urbanity, which is not the same as the art of creating, and not on an incidental art work for a readily identifiable user group. Should Beyond make use of an already existing work by Dennis Adams, a leftover from the earlier organized 'Panorama Utrecht' exhibition? Yes, since his stadium type seats which were dispersed at the time over the inhabited part of Leidsche Rijn symbolize the relationship of the new with the old city.

Systematically, we then began to pad out the different parts of the programme, helped in this by the newly formed Bureau Beyond, a quasi-independent, local government agency that supported the Artistic Team and was in charge of execution. Its support could be extended if activities warranted this, or reduced to a small core for day to day business.

It quickly became obvious that whenever we invited an artist to

develop a plan for some form of interaction with residents, like for instance as part of the 'Action Research' programme component, he or she invariably came up with a permanent monument. That was not the idea, but it quickly made us realize that flexibility and acceptance of pure chance can contribute greatly to a good result. And that which we wanted to impose on Leidsche Rijn, also applied to ourselves.

Moreover, we discovered that the artists we invited found difficulty grasping the extent and sheer scale of Leidsche Rijn and what we had in mind for the different parts of the programme. Here, putting on an exhibition, like 'Parasite Paradise', to clarify what a certain part of a programme was actually about proved to be a good choice. In this context the exhibition was used as a place for communicating through research and experimentation and then moving on from the results.

Much can be read in subsequent chapters about the whys and wherefores, the ups and downs and perceptions of the art programme. Not everything was successful. Not all parts of the programme worked. Generally speaking, however, Beyond achieved what it set out to achieve: a totally different use and approach to art within a large urban expansion project. Something that was praised, commented upon and followed from far beyond the Dutch borders.

Should anyone want to draw lessons for the future from this, a word of advice: leave much to chance; don't play safe; explore boundaries; accept failures, and if it fails, allow it to fail miserably, in such a way that you also learn a real lesson from it. And don't start a project like Beyond without having the exceptional qualities of a decisive and dependable, local department of cultural affairs.

Leidsche Rijn, Beyond bids farewell, the time has come.

Tom van Gestel
Chair, Beyond Artistic Team

**Foundation
Leidsche Rijn
Project Agency**

**Confirmation Master Plan
Leidsche Rijn, MAX2
(Riek Bakker), the Municipality
of Utrecht and BVR**

Beyond in time

20.10.1996

Brussel

La Marche
Blanche
Paul Marchall
Marc Dutroux

8 July 1994
Kim Jong-il succeeds his
father Kim Il-sung as the
leader of North Korea.

14 October 1994
Yasser Arafat, Yitzhak
Rabin and Simon Peres
receive the Nobel Peace
Prize.

3 March 1995
The UN mission in Somalia
is suspended.

11 July 1995
Bosnian Serb troops seize
the Muslim enclave of
Srebrenica in Bosnia-
Herzegovina, which is being
protected at the time by
Dutch UN soldiers, and
commit genocide, killing
7,500 men and boys.

Launch of the publication 'Art for Leidsche Rijn: A Snowball Worth 10 million', the advisory report of the Advisory Board of the Arts of the municipality of Utrecht on art in public space for the new housing development Leidsche Rijn

January 1997
Confirmation of Housing Development Leidsche Rijn

Discovery of archeological remains of the first Roman ship in De Balije, Leidsche Rijn

June 1997
Alderman of Culture Affairs department visits the exhibition 'Skulptur Projekte Münster'

4 December 1997
Start building Leidsche Rijn

cantz

MANIFESTA 1 Rotterdam The Netherlands 1994

SCULPTURE. PROJECTS IN MÜNSTER 1997

725.8 cat. 38

HATJE

documenta X - the book

London 02.05.97

Neo-Liberalism

Manifesta 1
Rotterdam

Manifesta 4
Frankfurt (D)

Documenta 10
Kassel

10 February 1996
The chess computer Deep Blue defeats world champion Garri Kasparov.

5 July 1996
The birth of Dolly, the first mammal to be successfully cloned from an adult somatic cell.

13 September 1996
Tupac Shakur is gunned down.

23 March 1997
Supporters of Feyenoord and Ajax soccer clubs meet near Beverwijk for a prearranged battle. The Ajax supporter Carlo Picornie is beaten to death.

11 December 1997
Drafting of the Kyoto Protocol as a supplement to the Rio de Janeiro Climate Convention

14 October 1998
Completion of the first house in
Leidsche Rijn

23 October 1999
Positive verdict of the
Advisory Board of the Arts on
re-placing the work Bunnik Side
by Dennis Adams in Leidsche Rijn

19 November 1999
The municipality of Utrecht
invites SKOR (the Foundation for
Art and Public Space) to
participate in the planning for
art in Leidsche Rijn

Pristina **Kosovo War**

Manifesta 2
Luxembourg

7 September 1998
Founding of Google Inc.

19 December 1998
The US House of
Representatives votes in
favour of impeaching
President Bill Clinton.

28 May 1999
After a process of
restoration lasting 22
years, Leonardo Da Vinci's
masterpiece The Last
Supper is exhibited once
again.

25 July 1999
Lance Armstrong wins the
86th Tour de France.

4 April 2000
Establishment of Project Team Beyond, chairman Peter Kuenzli

30 May 2000
The city council grants permission to the Leidsche Rijn Project Agency to develop a scenario for the arts in Leidsche Rijn

14 September 2000
The Project Team Beyond agrees upon a pilot study of the art programme in Leidsche Rijn, Terwijde

15 December 2000
In commission N55 works out the draft for LAND

31 January 2001
Launch of the scenario 'Beyond Leidsche Rijn: The Vinex Assignment for Art', the result of the research activities of the Project Team Beyond

11 March 2001
Seminar on art in Leidsche Rijn. The Project Team Beyond presents the concept of the assignment for art in Leidsche Rijn to an external group of architects, artists, managers and commissioners

8 June 2001
The council agrees to the Beyond scenario

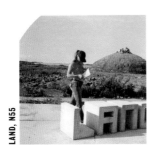

LAND, N55

BORDERLINE SYNDROME
Energies of Defence

Manifesta

New York **11.09.2001**

9/11

13

Manifesta 3
Ljubeljana (SL)

13 May 2000
Enschede fireworks disaster, essentially obliterating the neighbourhood of Roombeek.

7 November 2000
George W. Bush is elected President of the United States ('too close to call').

1 January 2001
Devastating fire in the bar 't Hemeltje in Volendam.

11 September 2001
Terrorist attack on the World Trade Center, New York City.

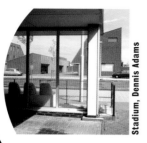

Stadium, Dennis Adams

1 December 2002
Official take off of Beyond
Installation of the artwork
'Stadium' by Dennis Adams on
different locations in
Leidsche Rijn

11 January 2003
Establishment of Bureau Beyond
(Beyond Office). Beyond moves
into the office on Beneluxlaan.

17 May 2003
Large public event surrounding
the discovery of the remains of
a Roman ship in Leidsche Rijn.

1 August 2003
Opening manifestation 'Parasite
Paradise' near the Information
Centre Leidsche Rijn.

16 August 2003
Opening event of LAND by N55 in
Terwijde

€

13.03.2002

The Hague

**Lib-Lab
Devastations**

MANIFESTA 4

Documenta11_Platform 5: Exhibition
Catalogue

Hatje Cantz

**Parasite
Paradise**
Leidsche Rijn

Prijs €2,-

1.8-28.9.2003
www.parasiteparadise.nl

**Roman ship, source:
Leidsche Rijn Project Agency**

Manifesta 4 Documenta 11
Frankfurt (D) Kassel

2 February 2002
The marriage of Dutch
crown prince Willem-
Alexander and Máxima
Zorreguieta from
Argentina

6 May 2002
Assassination of Dutch
politician Pim Fortuyn

15 May 2002
General election to the
House of Representatives
of the Dutch Parliament.
Fortuyn's party (LPF)
becomes the second
largest party of the
Netherlands.

20 March 2003
Large-scale bombing on
Baghdad by US and British
forces. The invasion
marked the beginning of
the Iraq War.

2004
Launch of the 'sales catalogue' WAPLA: The Art of Car Washing which was offered to potential car-wash operators.

17 March 2004
The city council confirms the Vision 'The Living Centre'.

9 April 2004
Installation of 'De Parasol' designed by Milohnic & Paschke in Vleuterweide.

16 May 2004
Housewarming party on the occasion of the opening of 'Nomads in Residence/No. 19', designed by Bik Van der Pol and Korteknie Stuhlmacher Architects.

3 July 2004
Opening of 'Paper Dome', attended by Japanese architect Shigeru Ban

4 September 2004
The Slovenian artist/architect Apolonija Šušteršič settles into 'Nomads in Residence/No.19' and starts her project 'Cinema/Studio'.

10th Anniversary of Leidsche Rijn

17 July 2005
Bike tour by night, on the occasion of Brite Bike by Jesús Bubu Negrón, from Utrecht/ Leidsche Rijn to Stedelijk Museum Bureau Amsterdam

3 September 2005
Opening exhibition 'Pursuit of Happiness', as well asthe opening of 'The Building' (Het Gebouw) designed by Dutch conceptual artist Stanley Brouwn in cooperation with Bertus Mulder

RMISSION VAN GOGH HIRSI ALI

29.08.04

The Building,
Stanley Brouwn and Bertus Mulder

Manifesta 5
Donostia–San
Sebastian (S)

2 November 2004
Assassination of film producer
Theo van Gogh in Amsterdam

George W. Bush is re-elected
as President of the
United States.

1 June 2005
Referendum on the
Treaty establishing a
Constitution for
Europe. The proposal was
rejected by the majority
of the Dutch electorate

12 January 2006
Confirmation of the Master Plan Leidsche Rijn Centre. There are plans for a skyscraper called 'Belle van Zuylen', 262 m high

1 April 2006
The children's museum Villa Zebra, Rotterdam, organizes the first exhibition 'Ikke, Ikke, Ikke' in The Building.

21 May 2006
Start of the long-term sculpture project Roulette on the Koehoornplein roundabout.

Start of the construction of the tunnel for the A2 motorway.

23 March 2007
The children's museum Villa Zebra, Rotterdam, organizes the second exhibition 'Heel Kapot' in The Building.

15 July 2007
A large one-day event at Castellum, Hoge Woerd: The Reserve (Het Reservaat) by artist Sophie Hope

5 November 2007
Inauguration of the railway stations Vleuten and Utrecht Terwijde, Leidsche Rijn

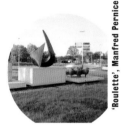

'Roulette', Manfred Pernice

HOUSE
BEYOND'S
FOR SALE

17 september t/m 5 november 2006
5 ontwerpen voor een Vip-woning
in Het Gebouw, Leidsche Rijn/Utrecht

sculpture
projects
muenster
07

DOCUMENTA
KASSEL
16/06—23/09
2007

Amsterdam

ICE
clos
we

Manifesta 6
Nicosia (Cy)
Cancelled

Sculpture
Projects
Muenster

Documenta 12
Kassel

21 May 2006
Premiere of the documentary film *An Inconvenient Truth* by former US Vice President Al Gore.

16 October 2006
Frits van Oostrom, as chair of the committee named after him, presents to education minister Maria van der Hoeven the list of historical icons dubbed the 'canon' of the Netherlands.

12 October 2007
Al Gore and the Intergovernmental Panel on Climate Change are jointly awarded the Nobel Peace Prize.

22 March 2007
Government minister Ella Vogelaar announces a list of neighbourhoods to receive special attention during her term of office. The restoration of these postwar neighbourhoods is to be paid for by housing associations.

25 May 2008
Celebration of 'First Day of the Park' in Leidsche Rijn Park.

3 June 2008
Opening of the new main 'yellow' bridge leading to Leidsche Rijn.

21 June 2008
'Alphorn Party' at the occasion of the new sculpture 'Meet You at the Mountains' by Maja von Hanno, Vasalisplantsoen, De Woerd

19 September 2008
Start of the layout of the main part of the Leidsche Rijn Park (De Buitenhof).

January 2009
'Observatorium' by Lucas Lenglet was chosen by inhabitants of Leidsche Rijn to become the final piece of art for the Sculpture Park Leidsche Rijn

14 February 2009
Opening show 'Out of Site But Not Out of Mind' in The Building. On request of Mathilde ter Heijne inhabitants from Leidsche Rijn show the objects they brought to become part of an artwork in the Sculpture Park Leidsche Rijn

26 March 2009
Confirmation of development plan Leidsche Rijn Centre North. The skyscraper Belle van Zuylen, designed by De Architecten Cie, is planned near the A2 motorway

16 April 2009
Opening exhibition 'Monstershow', the last presentation by Villa Zebra in The Building

23 April 2009
Opening festivities on occasion of the 'De Zingende Toren', a free standing bell tower with carrillon of glass, designed by Bernard Heesen (commissioned by the Municipality of Utrecht)

13 May 2009
As final round of the long-term artproject Roulette, Manfred Pernice installs a sculpture designed by himself.

11 September 2009
Opening of the Sculpture Park Leidsche Rijn, at the same time as festivities marking Beyond's final public event. The celebrations are part of the Uitmarkt, the opening festivities of the cultural season in Utrecht, in part held in Leidsche Rijn.

LEIDSCHE RIJN
BEELDEN PARK

17

Manifesta 7
Trentino (I)

3 October 2008
The Dutch government becomes holder of the Dutch parts of Fortis Bank.

11 October 2008
Collapse of the Icelandic banks Landsbanki. More than 400.000 depositors with Icesave accounts from the UK and the Netherlands are unable to access their money.

27 December 2008
Israel launches a military campaign in the Gaza Strip

20 January 2009
Inauguration of Barack Obama as the 44th President of the USA.

30 April 2009
Failed attack on the Queen of the Netherlands on Queen's Day.

5 June 2009
Biggest winner of the elections to the European Parliament in the Netherlands is the Party for Freedom (PVV) of right-wing politician Geert Wilders.

PROJECTS:

Beyond Programme

Action Research
The artists' accommodation
Nomads in Residence/No.19 is the
operating base for temporary projects
and interventions by artists in the
neighbourhoods already inhabited.

Director Artists
Beyond invites artists to contribute
ideas to the design of complex
infrastructure projects. These Director
Artists are expected to formulate a
creative solution for the assignment they
undertake.

Artist Houses
A number of artists have been invited to
respond to the urbanization in Leidsche
Rijn. They can do this by building a house
or by organizing a project.

Parasites
Parasites is the umbrella term for mobile
architecture and experimental forms of
light urban development. This ususally
involves flexible and moveable buildings
with a social function.

White Spots
Beyond has occupied a number of
building plots and terrains in Leidsche
Rijn. These White Spots on the map of
the district are thus temporarily
withdrawn from the building programme.
Beyond uses the White Spots to stage
art projects.

Looping
Looping includes a range of projects
that concern communication. Looping
aims to inform and involve the residents
and other interested parties in the
activities of Beyond. The website,
www.beyondutrecht.nl, is a component
of Looping.

Inspired by the F-side stands in the Galgenwaard football stadium, Dennis Adams had dozens of bright orange bucket seats descend upon the neighbourhoods of Langerak and Parkwijk. They were distributed haphazardly throughout the area, but not entirely at random, because they were all facing towards the same point in the distance: the centre of Utrecht. With this work of art called *Stadium*, Adams refers to the old Utrecht and seeks to establish a link between the old and the new communities. Do the people in Leidsche Rijn already have the feeling that they form a community, as do the supporters in the stadium? Or do they prefer to jump in the car and head back to the old city?

A previous version of this work appeared in the exhibition 'Panorama 2000' in Utrecht (Bunnikside, 1999).

Not everybody was pleased by the unusual placing of the brightly coloured seats, sometimes facing a wall or just behind a garden fence. Some of them were destroyed. In 2005 the seats were removed from the various building sites in Leidsche Rijn.

STADIUM
DENNIS ADAMS (VS)
2002, LANGERAK AND PARKWIJK

21

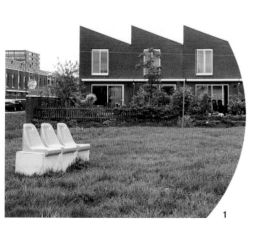

1

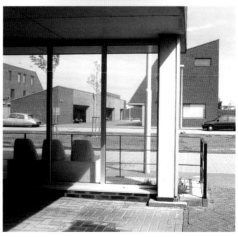

2

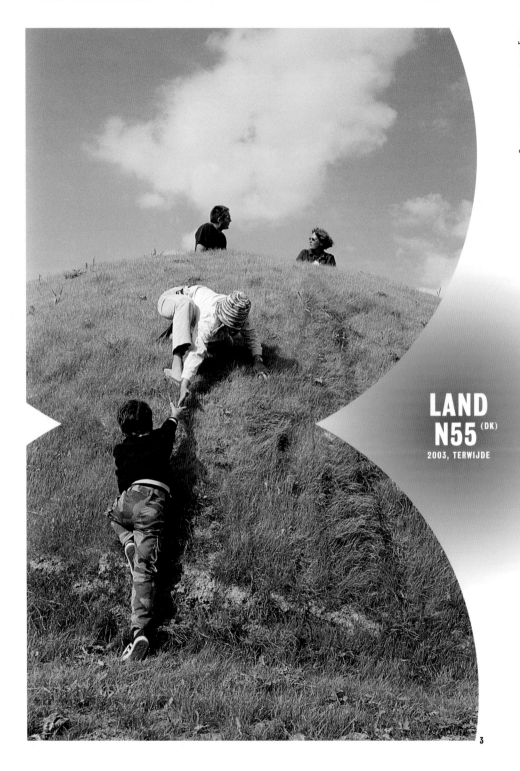

**LAND
N55** (DK)
2003, TERWIJDE

3

In 2002 Beyond temporarily appropriated a piece of land from Leidsche Rijn's building development programme. The 300-m2 plot was situated in a part of Terwijde that was not to be developed for a few years. In a sense the plans for Terwijde form a test case for the programme. The Danish artists' collective N55 were commissioned to give the plot of land, surrounded by water and with a bridge of its own, a temporary function. Their original plan to erect living modules where a completely self-sufficient lifestyle could be led was never executed. One of the reasons was that the aluminium constructions would, in this context, be too prone to vandalism. The area would then loose its 'open' character. The second proposal from N55 actually hooked into this fear of 'misuse'. They raised a hill, marked the area 'LAND' in poured concrete letters and stipulated that the 'white spot' was freely accessible to future Terwijde residents. LAND can be used for growing vegetables, giving parties or as a look-out post. The free offer of land for general use is in keeping with N55's belief that everything should be at the disposal of everyone and in the best democratic way possible. Since LAND was created six years ago, lettuces have been harvested, educational projects organized, sheep have grazed and birthday parties held. LAND is part of an area where a green space is planned. The possibility is being studied as to whether LAND can retain its current 'free' status within Terwijde's new greenbelt.

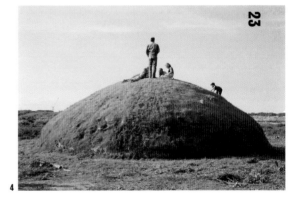

4

5

23

PARASITE PARADISE

AUGUST – SEPTEMBER 2003, LEIDSCHE RIJN

2012 ARCHITECTEN (NL)
VITO ACCONCI (USA)
MAXIME ANSIAU (F)
ANDRÉ VAN BERGEN (NL)
BIK VAN DER POL AND KORTEKNIE
STUHLMACHER ARCHITECTEN (NL)
KEVIN VAN BRAAK (NL)
BÖHM/SAFFER/LANG (GB/D)
EDUARD BÖHTLINGK (NL)
LUC DELEU (B)
EXILHÄUSER ARCHITEKTEN (D)
FISHKIN & LEIDERMAN (R)
HAP (B)
ED JOOSTING BUNK (NL)

ATELIER KEMPE THILL
ARCHITECTS AND PLANNERS (D)
KAREN LANCEL (NL)
ATELIER VAN LIESHOUT (NL)
MAURER UNITED ARCHITECTS (NL)
MILOHNIC & PASCHKE (D)
KAS OOSTERHUIS/ILONA LÉNÁRD/MENNO
RUBBENS (NL)
ROSEBOOM/WEEMEN (NL)
STEFANOS TSIVOPOULOS (G)
ROB VRIJEN (NL)
DRÉ WAPENAAR (NL)
WINTER/HÖRBELT (D)

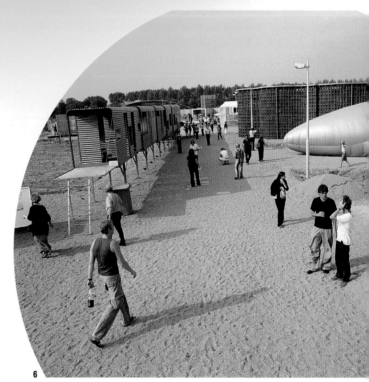

6

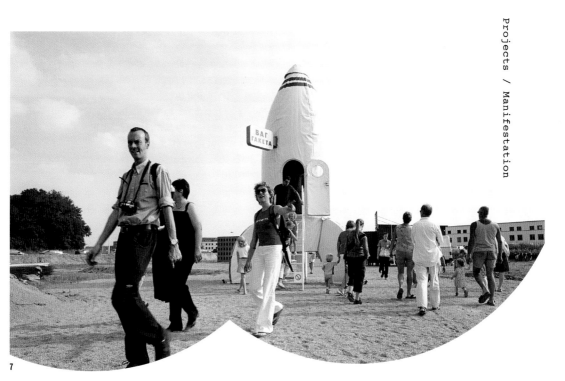

7

'Parasite Paradise' was Beyond's first exhibition in Leidsche Rijn. In the summer of 2003, a settlement was built on what was then waste land, next to Leidsche Rijn's Information Centre, based on a plan by the Belgian architect Luc Deleu. Along the 'main street', leading into a centrally located square, and in the field behind this, examples of experimental, mobile architecture were sited. For two months visitors could wander around this alternative environment, going out, sleeping and eating, as the parasite constructions housed every kind of facility expected of a large settlement. Along with 'dwellings' there was also a church, bar, cinema and theatre – facilities which Leidsche Rijn did not have at the time. The greenhouse and mobile farm supplied ingredients for dishes on the menu of the local open-air restaurant. Those who wanted to go on holiday could stay in a camping flat, for instance.

As well as an exhibition of experimental buildings, 'Parasite Paradise' explored alternative ways of living, working and coexisting. As such, the exhibition pre-empts Leidsche Rijn's ambition to become an important urban conurbation. After the exhibition some mobile structures were allocated a space in Leidsche Rijn for a few years. There on site the possibility of having certain cultural functions like a 'cinema', 'neighbourhood centre' or 'theatre' can be tried out.

The flexible and compact *parasites* avoid stringent legislation for housing and town planning, and can be erected on locations where housing is not (yet) tolerated.

They are made of light, often recycled materials, as is the case with the *Miele Space Station* designed by 2012 Architecten, which consists of old washing machines, or the *Lichtspielhaus* designed by Wolfgang Winter and Bertholt Hörbelt, made of stacked crates.

The creative way materials and flexible structures are used reveals the longing of artists and architects for the community to feel free. In 'Parasite Paradise' the designers tend to visualize their ideas about liberation by using mobile units that can easily be attached and applied to urban life.

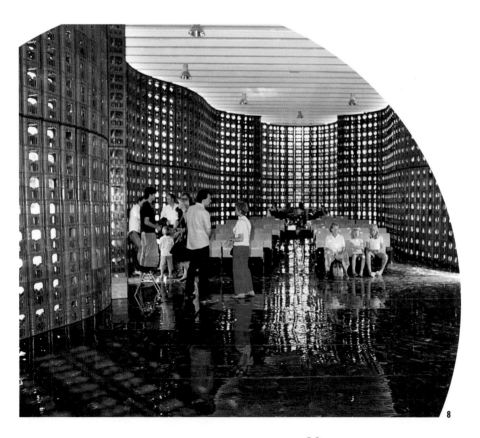

8

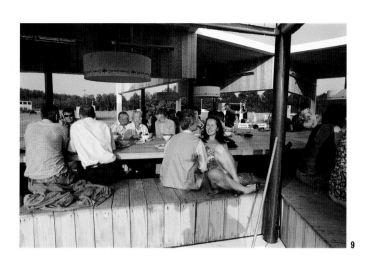

9

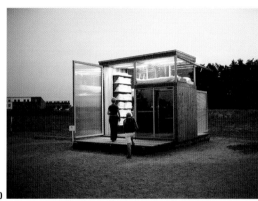

10

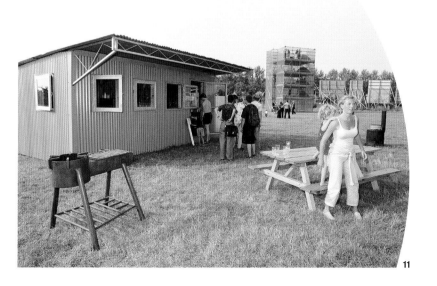

11

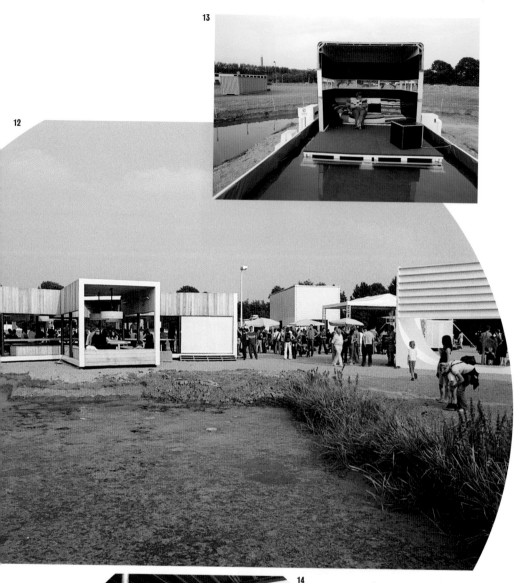

13

14

VIVA EL MONOPATIN MAURER UNITED ARCHITECTS (NL)

2003, DESTROYED

In the first instance the architectural installation *Viva el Monopatin* (long live the skateboard) was intended as a monumental homage to skating culture. The work was commissioned by Beyond for the 'Parasite Paradise' exhibition and afterwards was supposed to be given a site in the new district.

The dimensions of this snow-white installation were in keeping with those of a lorry, so that the halfpipe was relatively narrow. Moreover, the skateboard track at the top was enclosed by walls, which could create feelings of claustrophobia for the skater. But herein lay the challenge for the experienced practitioner. The work can be seen as a tribute to this dangerous art, in which skills are pushed to the limit. It is ironic that this aspect (dangerous art) also decided the fate of the work. The piece was exhibited as an art work at the Van Abbemuseum, Eindhoven, in 2005. It was never successful in being placed in Leidsche Rijn, as the work did not comply with strict safety regulations for outdoor equipment. The architects did not agree to its symbolic installation in a park (surrounded by a fence with a 'keep out' notice).

29

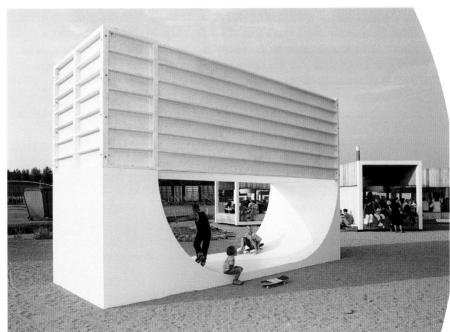

15

THE PARASOL
MILOHNIC & PASCHKE (D)
IN COLLABORATION WITH
RESONATORCOOP
2001–2004, VLEURTERWEIDE

The Parasol basically consists of two steel shipping containers. In collaboration with Resonatorcoop architectural agency, Milohnic and Paschke converted these into a kind of shelter with a wooden terrace, covered over with a construction of bamboo and Chinese parasols. Of all the *parasites* in Leidsche Rijn, this turned out to be the most mobile. During its travels, the form, originally designed for the exhibition 'Mobile Architecture on the Stork Site' (2001), underwent several modifications. A modified version of this mobile shed unit was shown at the 'Parasite Paradise' exhibition. The *parasite*, under the new name *The Parasol*, was then given a site on the edge of the neighbourhood of Vleuterweide, where it serves as a meeting point for local youth. It is run by Welzijnsstichting De Haar, a local social welfare agency, which organizes many activities there such as discos for young people. The *parasite* is both notorious and popular and for a while the parasol became the 'logo' of the agency.

The fragile Chinese parasols were replaced by a more durable version in 2005. Like the Chinese ones, the tiki-parasols conjure up images of exotic locations. In their turn, the uncompromising steel containers invoke the tough existence of a seafarer. Such ambiguity characterizes the pioneering life amid the heaps of sand in Leidsche Rijn. In 2007 *The Parasol* was taken over by Breukelen local council.

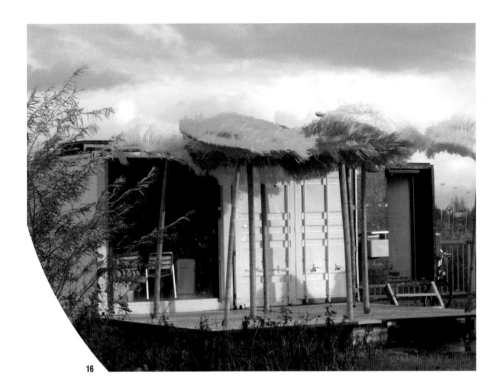

16

17

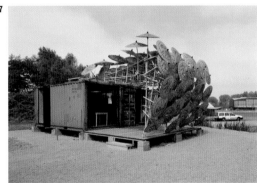

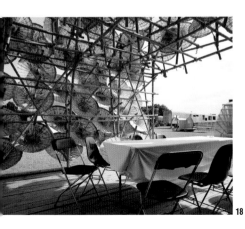

18

The Japanese architect Shigeru Ban prefers to build with light, prefab materials such as cardboard, paper and bamboo. The graceful structures and almost transparent materials create a diffused light and a floating effect. At night, when the lights inside are burning, this temple of culture takes on an enchanted, almost unearthly appearance.

The Dome, nearly 10 metres high and with a diameter of 25 metres, consists of a lightweight construction made of more than 700 cardboard tubes, over which a white canvas is stretched. The *Paper Dome* came into being through collaboration between Beyond and the mime company De Groep van Steen. Before coming to Leidsche Rijn it stood for three weeks in the vinex-location IJberg in Amsterdam, where it provided a venue for theatre productions. The *Paper Dome* is the first cultural facility for the residents of Leidsche Rijn. Cultuur 19, a joint venture of Utrecht-based amateur art organizations in Leidsche Rijn, is responsible for the programming and operation of the Dome. Since 2004 the Dome has played host to cultural activities such as the Leidsche Rijn Festival, a large festival for amateur art, a week of Children's Theatre, and the Arts and Interior Market, among other events. In the winter of 2005 it was even possible to skate on the temporary ice rink under the dome. Within a few years time the *Paper Dome* will be dismantled and removed to make place for the future centre of Leidsche Rijn.

19

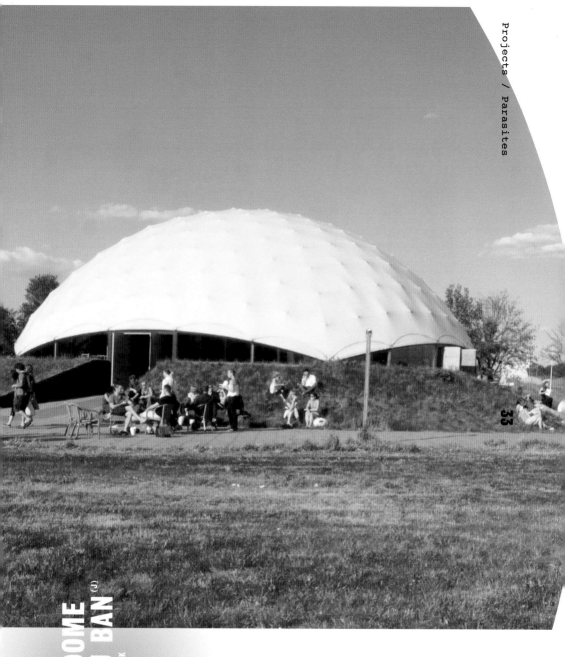

PAPER DOME
SHIGERU BAN (J)
2004, PARKWIJK

NOMADS IN RESIDENCE/NO.19 BIK VAN DER POL & KORTEKNIE STUHLMACHER ARCHITECTEN (NL)

2004, TERWIJDE

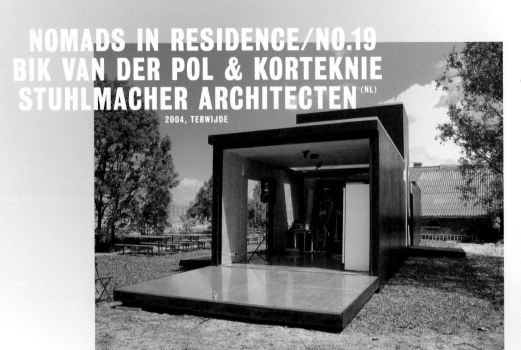

20

For artists Liesbeth Bik and Jos van der Pol, researching a location is a major starting point for their work. They regularly create situations in which artists and/or students meet each other, undertake research and exchange ideas. Their conceived *Nomads in Residence/ No. 19* is in keeping with this way of working. The mobile, multifunctional living/workspace is geared to temporary accommodation for one or more occupants. The design conforms to high standards of quality and is made to last: the solid, softwood construction can take a lot of wear and tear. The walls can be lowered to create passageways and terraces. If need be, the entire black box can be loaded onto a trailer and transported. It was originally designed for the exhibition 'Mobile Architecture on the Stork Site' (2001) and in 2003 was realized at the request of Beyond. During 'Parasite Paradise', *Nomads in Residence/No. 19* was used as artists' accommodation and continued to be used as such when it was installed in the neighbourhood of Terwijde (2004). Many artists used the accommodation as a base when carrying out their projects as part of the Action Research programme.

In 2008 the area around Den Engh was designated for development and for this reason *Nomads in Residence* was relocated to 't Zand. The management and running of Nomads was taken over in mid-2009 by the Via Vinex agency, which organizes cultural projects in Leidsche Rijn.

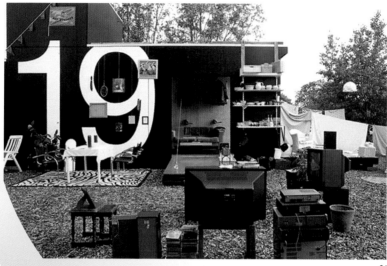

21

NEW RESIDENTS

2004, TERWIJDE

35

In the context of the Action Research-Programme Beyond invites young artists to be artists-in-residence in Leidsche Rijn. As temporary occupants of the parasite *Nomads in Residence/No.19* the participants have a chance to investigate on location and create short interventions in the surrounding area. In this way the public can come into direct contact with the art projects in the neighbourhood. The New Residents' findings appear on the Beyond website.

Marjolijn Dijkman and Wouter Osterholt researched the night scenes in Leidsche Rijn and displayed a number of environments, made out of useable items found in the new residents rubbish bins, in their own 'furniture strip' just outside the *Nomads in Residence/No. 19.*

Paul Segers made the videocollage Hollands Agriculturele Scenario's, about farmers who had to give up land in and around Leidsche Rijn for the construction of this new district. It represents the farmers' search for new land.

22

Paul Kuipers, Mark Mantingh and Mark van Steenbergen are three artists who worked together for this occasion to research urban processes.
Dossier Droomhuis consisted of short interventions in the area around the *Nomads in Residence/No. 19*. They, for example, cut out the outlines of the word DROOMHUIS (dreamhouse) in the grass.

The artist Tilmann Meyer-Faje photographed places with 'temporary nature' in Leidsche Rijn. His imaginary series of postcards Groeten uit Leidsche Rijn maps this characteristic location.

David Gibbs recorderd the 'traces' of his thoughts and actions during his stay in Leidsche Rijn. These can be seen as impressions of a place still in the making.

For the audio artproject *Ein Lächeln ist mehr wert* the artist Lin Shih Ying found inspiration in the traffic of lorries,

diggers, and the chattering of meadow birds. The audio fragment, installed at the website of Beyond, starts with the romantic, christian hymn *Morning has broken*, in the version Cat Stevens brought in at 1971. Little by little the sounds of the piano and singing are drowned by the noise of roaring engines and scraping metal.

Many other artists came to visit Leidsche Rijn and resided at the mobile home in Terwijde, conducting research for their projects. In some cases the context differed. In August 2006 a group of Georgian artists visited the Netherlands in the frame of the exchange project 'Georgia here we come!'. Staying in Leidsche Rijn and becoming acquainted with the long-term artproject Beyond were part of their exploratory expedition in the world of arts.

The project *Cinema/Studio* was first and foremost meant as preparatory research into the building of an artist house in Leidsche Rijn. The Slovenian artist Šušteršič took up residency in the mobile living/working space, *Nomads in Residence/No. 19*, designed by Bik Van der Pol and Korteknie Stuhlmacher Architects, which was already installed in Terwijde. She tested its hybrid potential for living and working in a simultaneously private and public domain. The 'nomads' played host to a cinema for children, while at the same time serving as an artist's studio, living accommodation, and meeting space. The cinema, with a children's programme compiled by the Holland Animation Film Festival (HAFF), made the house accessible to the public. By so doing Šušteršič answered the call for more facilities in the young neighbourhood on the one hand, while using the cinema visits for her research into the social environment of mothers with young children in Leidsche Rijn on the other. During the screening, mothers were invited to exchange their thoughts with the hostess on Living in Leidsche Rijn. In addition to the mothers and children, Šušteršič received weekly guests, experts in fields ranging from urban development to gender issues. With her conversation partners she addressed questions such as: 'How is an experience of urbanity formed?' and 'Which social and economic factors play a role in the development of new facilities?' The residency was concluded with a festive presentation of animated films, made by the children from the neighbourhood during the workshops.

Šušteršič did not literally construct the house. As she puts it: 'At the end we didn't build the house, we performed it!' She will complete her Action Research-project in 2009 with a publication: *Cinema/Studio. A Notebook for Spatial Research – Case Study: Leidsche Rijn, Utrecht.*

23

CINEMA/STUDIO
APOLONIJA ŠUŠTERŠIČ (SI)
2004, TERWIJDE

37

24

The Puerto Rican artist Jesús Bubu Negrón planned to provide Leidsche Rijn with its own unique bicycles. Just like the white bicycles in Amsterdam and Otterlo, the intention was for the bikes in Leidsche Rijn to start a new story, the beginning of a 'new myth'. "A place only comes to life when it has its own stories", says Negrón. Negrón stayed temporarily in the *Nomads in Residence/ No. 19*, which he partially converted into a bicycle workshop. The residents of Leidsche Rijn could have their bicycle transformed into a trendy *Brite Bike*, a bicycle completely covered with reflective coloured tape.

On the last night of his stay, Negrón, the Beyond-team and some of the residents went out on a *Brite Bike*-tour to Amsterdam, where he participated in the group exhibition 'Tropical Abstraction' in the Stedelijk Museum Bureau Amsterdam. There, he presented, among other things, his own *Brite Bike*, referring to the project in Utrecht.

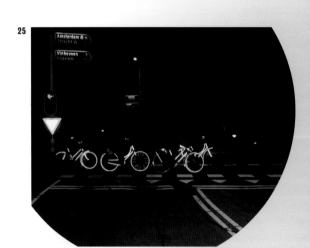

25

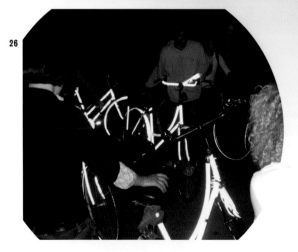

26

BRITE BIKE
JESÚS BUBU NEGRÓN (PUR)
2005, TERWIJDE

THE TERWIJDE COOPERATIVE SILKE WAGNER & SEBASTIAN STÖHRER ^(C)
JUNI/JULI 2006

27

In 2006 German artists Silke Wagner and Sebastian Stöhrer held open house in Terwijde for three weeks. Under the slogan 'Everyone is an expert', Wagner invited local residents of Leidsche Rijn to pass on their specialist skills to their fellow neighbours. *Nomads in Residence/No. 19* also served as a platform for the project. The activities, thought up by the residents, ranged from a 'Make your own didgeridoo' workshop, dance and singing lessons to a lesson in mandala drawing. The high divorce rate in Leidsche Rijn led to a get together of 'convivial ex-dumpers'. This playful variation on the idea of the 'ex-pert' was intended to give singletons a positive twist to all their lost loves in this *Vinex* neighbourhood. Under the supervision of artist and cook Stöhrer, Never Ending Soup was prepared daily, made from fresh ingredients provided by the residents themselves.

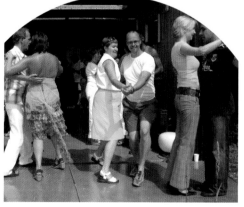

28

'Dear Readers, In your hand you have the very first example of the *Vicky*, the new magazine about *Vinex* life, brimming with art, culture, shopping and lifestyle, geared to the modern *Vinex* resident.' Thus begins the first column by Vicky Vinex on Beyond's website in 2005. The regular monthly column hovers between a comic strip and virtual real-life animation. The character, Vicky Vinex, interpreted by theatre-maker Daphne de Bruin, is a flamboyant inhabitant of Leidsche Rijn, who in her 'letters' reports on all her adventures, experiences and fantasies about life in 'El Ar' (Leidsche Rijn).

Vicky is a product of Looping, the communication strategy of Beyond and is based on a game with real and fictitious characters and situations. Vicky Vinex's contribution includes 15 columns in total. The final one concludes with the announcement that she has conquered the real stage with her one-woman show and is moving to 'the largest *Vinex* location in the world'. In May 2006 Daphne de Bruin, along with Joop van Brakel, brought *Vicky Vinex* to the stage in a production by the Utrecht theatre company Growing Up in Public.

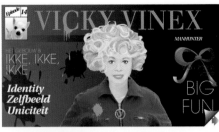

VICKY VINEX
DAPHNE DE BRUIN (NL)
2005–2006, WWW.BEYONDUTRECHT.NL

29

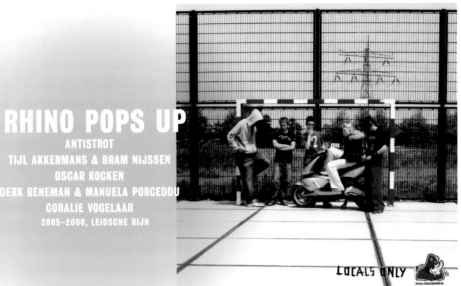

RHINO POPS UP

ANTISTROT
TIJL AKKERMANS & BRAM NIJSSEN
OSCAR KOCKEN
DERK RENEMAN & MANUELA PORCEDDU
CORALIE VOGELAAR
2005–2006, LEIDSCHE RIJN

LOCALS ONLY

In 2005, under the banner 'Rhino Pops Up', a group of young visual makers (graphic designers, photographers and artists), in the role of Rhino, were invited to make temporary interventions in the street culture of Leidsche Rijn. The project was chiefly aimed at the growing group of teenagers in the neighbourhood. It is precisely this group of still unorganized and elusive youngsters that was interesting for Rhino Pops Up. These young people are always creating new and unexpected public spaces, not only through physical and symbolical appropriation of spaces, but also through their easy interaction with all the latest information technology. The street forms the work terrain and subject matter of the Leidsche Rhinos. The short interventions, whether or not in dialogue with the local youngsters, took on many different forms. In 2005, for instance, under the direction of Derk Reneman and Manuele Porceddu, a 'street painting' was made by making skid marks with scooters on a piece of tarmac. The Rotterdam artists' collective Antistrot staged an action around the setting up of a shooting range in Leidsche Rijn. On the website www.leidscherhino.nl, the Rhinos have a platform for a chat-group and a young people's virtual newspaper.

Notwithstanding, Rhino's activities in Leidsche Rijn were insufficiently supported and the budget too tight for these. After a year the Rhinos abandoned these.

On the spot where the Leidsche Rijn Centre will be built in a few years is an exhibition pavilion designed by artist Stanley Brouwn. The design of this elder statesman of Dutch conceptual art is extremely simple: two crosswise overlapping blocks. The building's dimensions are taken from the 'Brouwn foot', his own unit of measure which the artist uses as an alternative to the metric system. The space was executed with the collaboration of the Utrecht architect Bertus Mulder.

The Building opened in 2005, during the visual-art exhibition 'Pursuit of Happiness'. Since then it has been in use as a try-out museum for the area, with various art institutions and private initiatives being invited to organize exhibitions. The pavilion is used intensively by Villa Zebra children's museum and by Utrecht art-promoting bodies like the CBK and the Genootschap Kunstliefde. The Curatorial Training Programme run by Amsterdam's De Appel museum also uses *The Building* for its end-of-term show.

Even though the pavilion was built as a temporary structure, *The Building* will be saved for Leidsche Rijn. It is included in future plans for the municipal centre, where the farm and summerhouse will also be given a site. The local council is in talks with the Central Museum, Villa Zebra and Via Vinex on a future programme for *The Building*.

THE BUILDING
STANLEY BROUWN
IN COLLABORATION WITH
BERTUS MULDER
2005, PARKWIJK

31

42

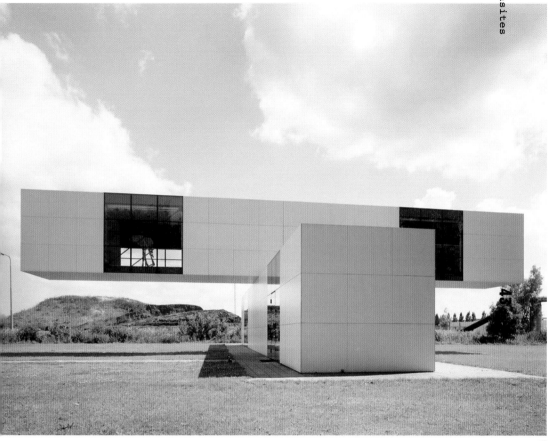

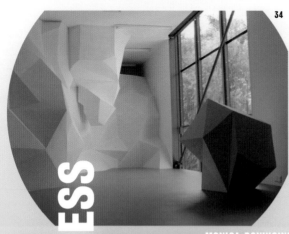

34

PURSUIT OF HAPPINESS

SEPTEMBER–OKTOBER 2005, HOGEWEIDE

MONICA BONVICINI
ESRA ERSEN
JAKOB KOLDING
GUILLAUME LEBLON
ERIK VAN LIESHOUT
CLAUDIA AND JULIA MÜLLER
LIBIA DE PÉREZ DE SILES DE CASTRO AND
ÓLAFUR ÁRNI ÓLAFSSON
TOMAS SARACENO
BARBARA VISSER
SOL ARAMENDI
JOHN BOCK
PERSIJN BROERSEN AND MARGIT LUKÁCS
LOULOU CHERINET
DAGMAR KELLER AND MARTIN WITTWER
QUIRINE RACKÉ AND HELENA MUSKENS
ANRI SALA
CORINNA SCHNITT
SANTIAGO SIERRA
MARIJKE VAN WARMERDAM

35

The second large cultural event 'Pursuit of Happiness' continues on from the themes raised in the first Beyond-event in 2003. 'Parasite Paradise' was about alternative forms of architecture and town planning, the hardware of Leidsche Rijn. In 2005 the event concentrated on the software, the people, about their ideals, dreams, and desires. What is happiness in a new Dutch neighbourhood at the start of the 21st century? And what do artists have to say about this in relation to Leidsche Rijn? The event took place in and around the the exhibition pavilion by Stanley Brouwn.

36

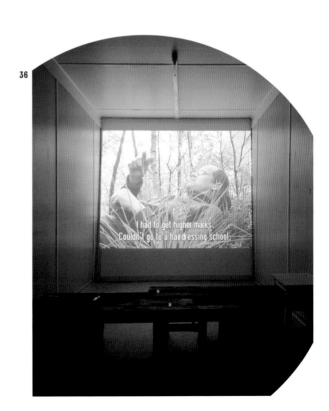

The video presentations show different views on the idea of the pursuit of happiness. The documentary film *Celebration* by Quirine Racké and Helena Muskens, for example, concentrates on the social life in the small idyllic town of the same name that was built in the spirit of Walt Disney. The video *Dammi I Colori* by Anri Sala – which shows the transformation of grey blocks of flats in Tirana into blocks painted in colourful patterns – raises the question of whether or not art contributes to a better society. The impression left by Aernout Mik's video installation is not that rosy: out on the street, where boredom and refractoriness seem to rule, grimness easily turns into teasing, badgering and hooliganism.

Some of the artists invited to realize a work for 'Pursuit of Happiness' did action research in Leidsche Rijn, like Monica Bonvicini and Esra Ersen. Or the work was meant as a case study on living in a more existential way. In Barbara Visser's video *Twee Projecties/ Two Projections*, a lady of advanced age motivates her preference for the modernistic style of her interior. Her words betray opinions on 'how to live' in a proper and responsible way. In the autobiographical video *UP!*, Erik van Lieshout addresses questions such as: 'What is necessary to make one happy?'

Other contributions were related more to notions on architecture, as was the floating, balloon-like 'garden' by Tomas Saraceno and the carved 'cliff' that Guillaume Leblon made for the interior of *The Building*.

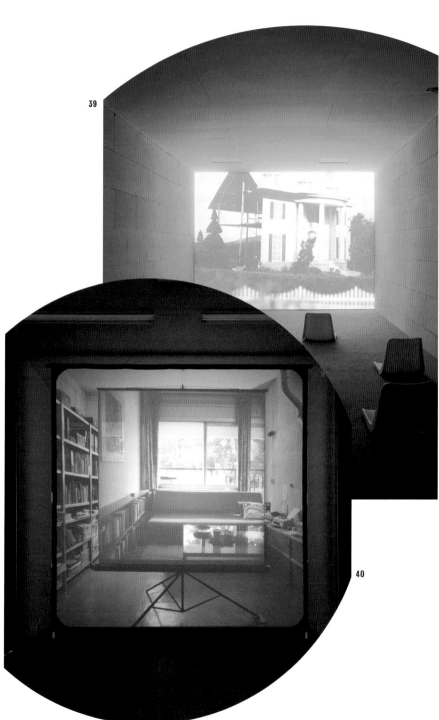

39

40

ROULETTE
MANFRED PERNICE[D]
2006, KOEHOORNPLEIN

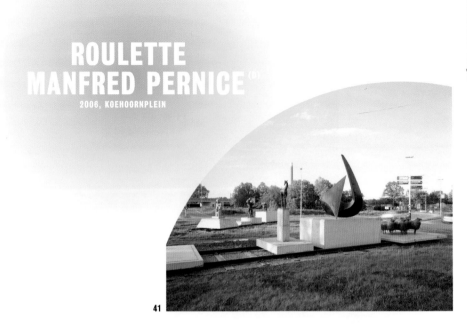

41

The long-term sculpture project *Roulette* started in May 2006. Beyond invited the German artist Manfred Pernice to make a selection from the council's collection of public art, and to exhibit these works for a few months each on a temporary roundabout. For this roundabout, which leads the traffic from the old city into Leidsche Rijn, Pernice designed a flexible system of pedestals, which make it possible to display several works on the roundabout simultaneously, and in a variety of constellations. The selected works range from bronze sculptures to concrete seating elements, from figurative statues to abstract 'playground' sculptures. Pernice is responsible for the selection and display of the works. The six 'rounds' he made reveal his fascination for different styles and themes in the history of monumental sculpture. *Roulette* shows how artworks function in, and derive meaning from, the context in which they are placed. Pernice creates a form of 'sculptural choreography' in which the mutual relationships between the sculptures are constantly changing.

The selected sculptures were temporarily removed from their locations in Utrecht to the roundabout in Leidsche Rijn, leaving empty spaces in the old city. In these neighbourhoods the removals sometimes gave rise to indignation and demonstrations of protest, but also heightened feelings of empathy; all these different emotional expressions show that art in public space is part of a complex field of forces.

In 2009 Pernice installed the sixth and last edition of *Roulette*. For this occasion he made his 'own work' using the concrete pedestals. In 2010 the temporary roundabout will be removed to make way for infrastructure work on the new Leidsche Rijn Centre. This will bring *Roulette* 'the presentation' to a close.

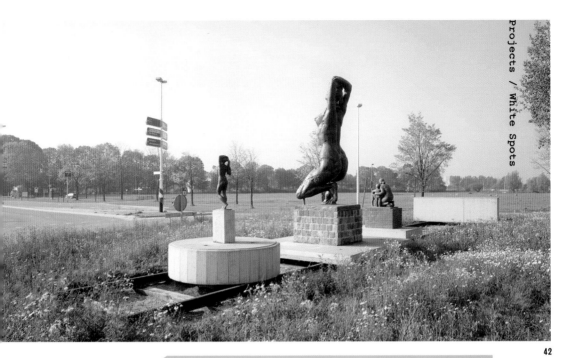

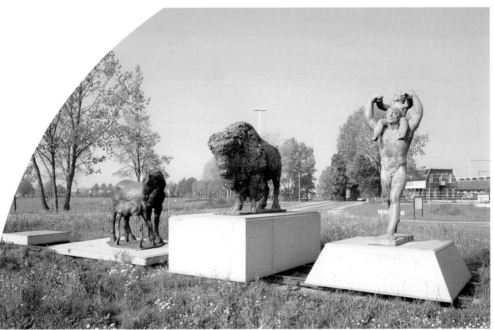

43

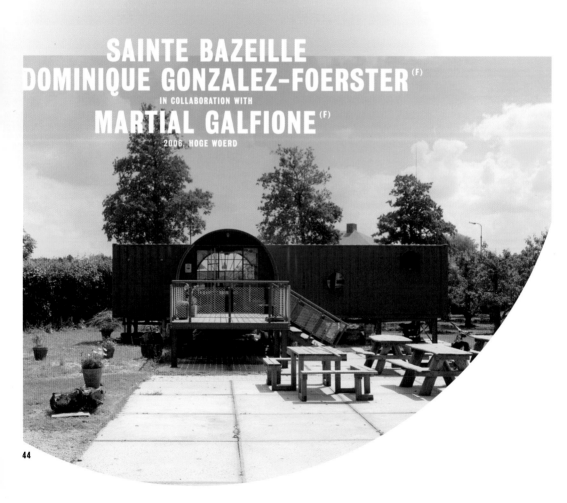

SAINTE BAZEILLE
DOMINIQUE GONZALEZ-FOERSTER (F)
IN COLLABORATION WITH
MARTIAL GALFIONE (F)
2006, HOGE WOERD

44

The design of the two so-called *parasites* by French artist Dominique Gonzalez-Foerster was originally intended as a modular system for mobile living/working spaces. The name Sainte Bazeille is taken from the inscription on a passing lorry and also reappears as such on the wall of the steel container that forms the basis of the buildings. The mobile architecture consists of two intersecting forms: a horizontal, cylindrical silo has been inserted at right angles to, and half imbedded in, a rectangular steel container. For the artist these are both symbols of labour, whereby the silo refers to the farmer and the container represents industry. In the original design the silo would accommodate a bedroom and sanitary facilities. In Leidsche Rijn, however, the space is adjusted to suit its public function.

The two units are situated in an old orchard, in an exceptional location from a cultural-historical point of view. The remains of a Roman castellum and bathhouse were uncovered on this spot. The public function of the *parasites* is related to this historical significance.

One is used as a presentation space for the centre for nature and environmental education, the other for archaeological presentations. In anticipation of their future use as House of Culture (Cultuurhuis Hoge Woerd), the *parasites* will retain their present function.

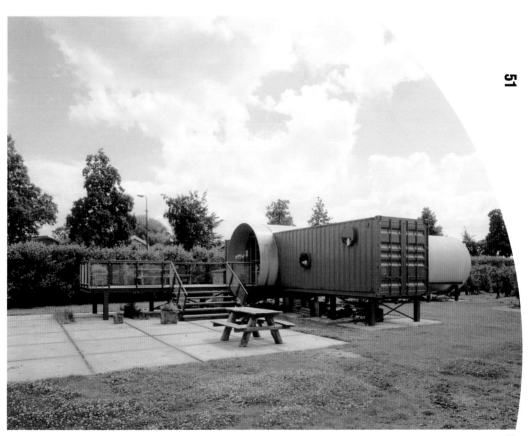

HOUSE FOR SALE

HANS AARSMAN IN COLLABORATION WITH ERIK KESSELS (NL)
DROOG DESIGN (NL)
ATELIER VAN LIESHOUT (NL)
MARKO LULIĆ (AT)
NL ARCHITECTS (NL)
SEAN SNYDER (VS)
MONIKA SOSNOWSKA (PL)
BARBARA VISSER (NL)

SEPTEMBER-NOVEMBER 2006,
EXHIBITION IN 'THE BUILDING'

46

47

48

49

In 2005, eight visual artists and architects were invited to make a design for a house on a specially reserved building plot in Leidsche Rijn. The house would have a typology that made it distinct from other dwellings: as if regarding a house for a VIP (a mayor, a film star, a footballer). In addition, there had to be an indication of a clear view of the relationship between the (residential) house and Leidsche Rijn. And, a private client or property developer would eventually realize the design.

A jury assessed the first preliminary sketches, three of which were selected for development into a provisional design, namely those by Hans Aarsman and Erik Kessels, Monika Sosnowska, and Barbara Visser.

The eight preliminary sketches and three provisional designs are being presented to the public in a small exhibition, 'House for Sale', in *The Building*. Visitors from Leidsche Rijn are then able to choose from the three provisional designs. The design with the most votes will be realized, if a client can be found.

LEIDSCHE RIJN CASTLE
HANS AARSMAN &
ERIK KESSELS (NL)
2006

The design by Hans Aarsman and Erik Kessels received the most votes. Raised in scarlet brick, this international 'safe house for free speech' is intended as a residence for people who think of clever solutions to the most wide-ranging problems. The design, which includes the provision of guest accommodation, conference rooms and a library, stipulates that responsibility for the running, programming and management of the castle also be included in its realization. Although a client was found who was willing to build the castle, he was unable to guarantee the content-related fulfilment of the project, at which point the plan perished.

50

A client was found for a different design, *Villa Sculptura*. The house consists of a giant concrete base that supports two living-sculptures in the form of a head and a womb. The concrete structure is composed of prefabricated sections of a multi-storey car park. The client, however, withdrew when it emerged that the design was incompatible with the urban development plans for the building plot and would require far-reaching alterations. On the initiative of the property developer Leidsche Rijn Project Agency, a search is now underway to see if another client can be found for *Villa Sculptura*.

VILLA SCULPTURA
ATELIER VAN LIESHOUT (NL)
2006

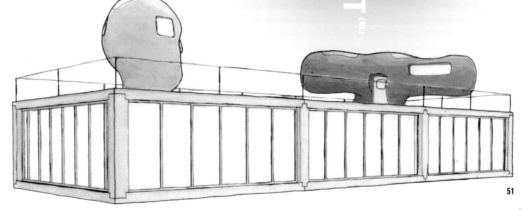

Imagine being able to travel a thousand years into the future. We find ourselves in 3007 and archaeologists are about to rediscover the Leidsche Rijn area. What will they find and how will Leidsche Rijn look in the future? With these questions in mind, Sophie Hope began her study into 'A Future Archaeology of Leidsche Rijn'. At first the artist thought of creating a play written by and for Leidsche Rijn residents, featuring the hopes and fears of those that live in this new district. Ultimately no play came out of this original plan, but a one-day amusement park: *The Reserve*. All parts of the day's programme were created, in keeping with Hope's concept, in collaboration with residents and local organizations. On Sunday, 15 July 2007, some thousand people visited the amusement park, where they could get acquainted with a real life family from 2007; the remains of a Wailing Wall symbolizing the separation of religions; a unique off-road vehicle of the period and fruit that still used to grow on shrubs and trees.

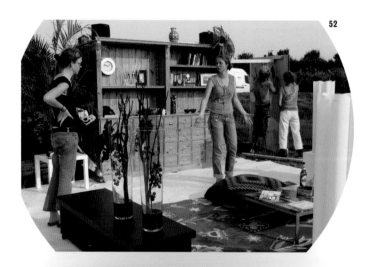

52

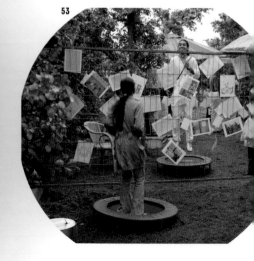

53

THE RESERVE
SOPHIE HOPE (GB)
15 JULY 2007

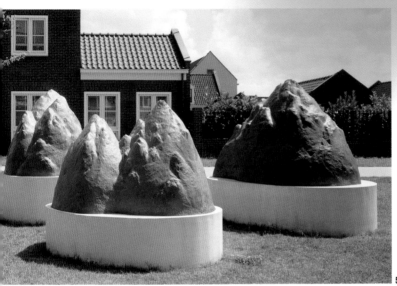

MEET YOU AT THE MOUNTAINS
MAJA VON HANNO[(N)]
2008, DE WOERD

54

De Woerd lies in an area where, in the past, the scene was set by fields and orchards. Here, Bouwfonds-Fortis is developing a large number of houses around courtyards and small squares that together radiate the pleasant atmosphere of a village. At the request of Bouwfonds-Fortis, Beyond is taking charge of developing an art commission in this district, which will be funded largely by the Bouwfonds.

Previously, in 2006, artist Maja von Hanno conducted a study into this traditionally rural greenbelt in the framework of the Action Research programme. For Beyond this was reason enough to ask Von Hanno to make a sketch plan. *Meet You at the Mountains* is a small-scale landscape that consists of three separate 'mountain ranges' through which roads gently meander. The mountains, placed on plinths, are simultaneously either semi-abstract sculptures or easily recognizable *landmarks* of a meeting place. The work stands in a temporary location. When the building activities are completed the piece will be moved to its permanent location on the north side of the Vasalisplantsoen, near the entrance to the district.

In 2007 Beyond invited artist Melle Smets to look at youth culture in Leidsche Rijn. He examined the much heard remark that young people just hang around and create a nuisance for the neighbourhood. After his research into the district, Smets concluded that the young people's behaviour was in no way exceptional, but rather the systematically arranged public space afforded little in the way of anything unexpected or adventurous for them. Local youth missed the undesignated spaces. Along with the organization Culture 19, Smets then drew up a series of 'Check Your Space' workshops which were held in three secondary-modern schools in Leidsche Rijn. The pupils undertook a study of their surroundings and presented ideas for ideal dream locations on the workshop's website www.sjekjeplek.nl.

In June 2008, the young people's plans were submitted to a jury in which the local police force, neighbourhood committee and youth workers were represented. Leidsche Rijn's neighbourhood agency is exploring whether one or more of the designs can be executed. In 2009 Smets recorded his findings in *Controle Design. Hard Kijken in Leidsche Rijn* (*Monitoring design. Looking hard at Leidsche Rijn*), a publication devoted to the new district.

SJEK JE PLEK
MELLE SMETS (NL)

55

SCULPTURE PARK LEIDSCHE RIJN

2009, LEIDSCHE RIJN PARK

MATHILDE TER HEIJNE (NL)
ZILVINAS LANDZBERGAS (LT)
LUCAS LENGLET (NL)
DANIEL ROTH (D)

FERNANDO SÁNCHEZ CASTILLO (SP)
WILLIAM SPEAKMAN (NL)
ROB VOERMAN (NL)

Leidsche Rijn is nearing completion. The art programme Beyond has always been characterized by temporary projects, but will round off with the realization of a number of permanent artworks. After 2006, Beyond focused its attention on the Leidsche Rijn Park, partly due to the desire to instigate the creation of a contemporary sculpture park. This large, versatile greenbelt in the heart of Leidsche Rijn will be used by local residents intensively for sports, walking, playing and cycling. Adriaan Geuze of West 8 landscape architects produced the design. The park consists of various main sections. The Binnenhof is the heart of the park and will grow into a classical municipal park. In the Buitenhof the decision was made to allow nature to develop. The Lint (ribbon) is a 30-m-wide green strip that encircles the park, with a wide path for walkers, cyclists and skaters. And with the Vikingrijn, the original course of the Oude Rijn (Old Rhine) River is restored. The park will be laid out in phases.

In consultation with Adriaan Geuze, the development of a municipal park was given an interpretation in which art and culture are intertwined, a combination that has many high-profile examples in the history of parks. As a guiding principle for the art commissions in the park, Beyond chose the book The *Possibility of an Island* (*La possibilité d'une île*, 2005) by French author Michel Houellebecq. The book conjures up an image of a 'new world', built on the remains of human civilization, destruction and decay; an 'island' that will bring forth a new society, which will itself, one day, belong to history.

Seven artists from the Netherlands and abroad were eventually selected to realize a piece for the park. As an extra literary art project, Arnon Grunberg is temporarily lying low in Leidsche Rijn, to serve as a chronicler of everyday life in this district. The first works will be realized in the summer of 2009. The expectation is that the sculpture park will be extended in the future. Then the art commissions will fall under the Fonds Stadsverfraaiing (Urban Embellishment Fund) of the municipality of Utrecht.

Mathilde ter Heijne takes her inspiration from archaeological finds, such as those made in Leidsche Rijn. She is interested not only in the 'chance' remains of a civilization, but also in the active use of the ground as a place to store and safeguard things, and the rituals that sometimes accompany this practice. Ter Heijne wants to create new meaningful places in the park, together with the residents of Leidsche Rijn. Residents neighbouring the park contribute a personal item somehow connected to an experience from their life in Leidsche Rijn. A number of these objects will be cast in bronze. These 'sculptures' will then be committed to the ground. The objects will be in underground 'display cases', which allow them to remain visible in the future.

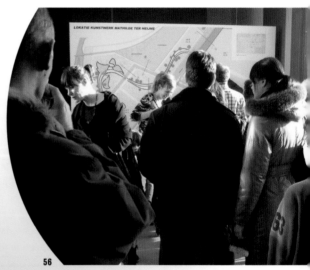

56

OUT OF SIGHT, BUT NOT OUT OF MIND (WORKING TITLE) MATHILDE TER HEIJNE (NL)

2009

Fernando Sánchez Castillo belongs to the generation of Spaniards born during the dictatorial regime of Franco. Themes such as oppression, revolution and liberation recur frequently in his work. For Leidsche Rijn he created a contemporary monument to democracy. He was guided in this by images of battered and burned-out car wrecks during riots in large cities. *Barricade* is a life-sized blockade such as those seen in the 1968 student uprisings in Paris and Turin: a *deux-cheveaux* and a Fiat 500 lie amid a chaos of car parts, flags and lumps of rock. The life-sized work will be placed as a roadblock in the middle of the central through road in the Binnenhof. The work refers to pockets of resistance and bloody battle, somewhere, far away from the peaceful park. But the piece also refers to other, more traditional monuments in which power and triumph are glorified, such as equestrian statues and obelisks.

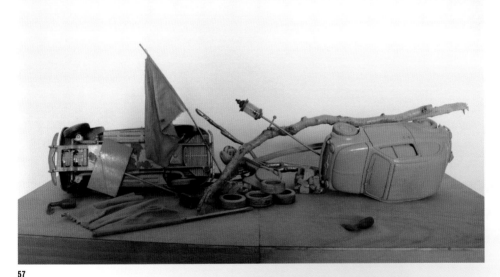

57

BARRICADE
FERNANDO SÁNCHEZ CASTILLO
2009

For Leidsche Rijn, Rob Voerman designed a stylized ruin, which he 'brings to life' by playing with the effects of light and glass. Particularly at night, the violet lighting gives the work a subdued aura and the tower-like form an almost religious connotation. The sculpture brings together suggestions of decay, utopia and faith. The work is in keeping with previous projects in which a dialogue is sought between the old archaic country life and the modern, highly developed society of today. In recent years his ambition to alter or manipulate reality has also led to works that can actually be put to use, as in this case.

UNTITLED
ROB VOERMAN (N
2009

58

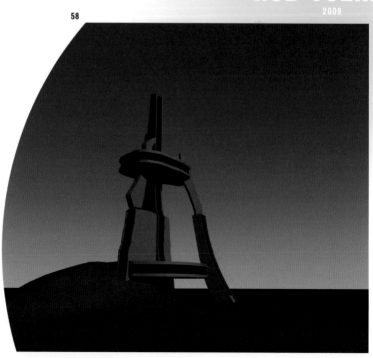

The remains of primeval forests found in Leidsche Rijn form a basis for the work by William Speakman. But so does the planting of new trees in the park, which will take several decades to become a mature forest. His *Wood Chapel* was originally conceived as a place to store wood. But the open wooden construction was eventually designed as a kind of chapel, with decorative murals on the inside showing themes derived from nature and folklore. This makes the interior exude an elevated atmosphere. The fine aesthetics and traditional craftsmanship are typical of Speakman's method of working. He wants the visitor to 'feel' the space and create a strongly individual experience.

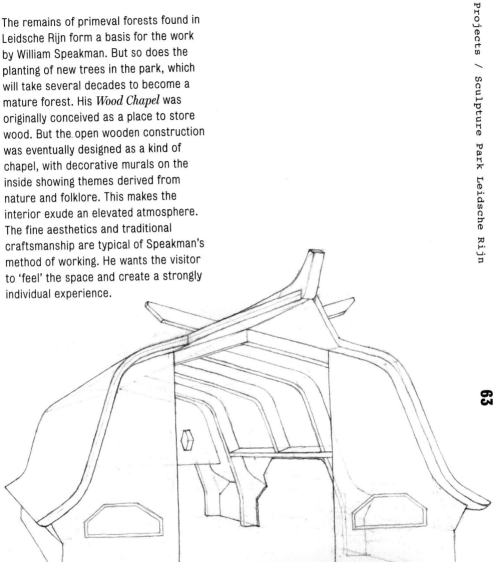

59

WOOD CHAPEL
WILLIAM SPEAKMAN
WITH PAINTINGS BY
GIJS FRIELING
2009

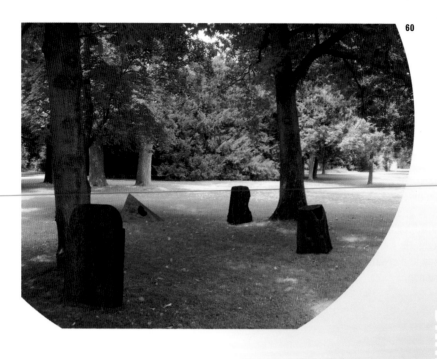

60

ANONYMOUS MONUMENTS
DANIEL ROTH (D)
2009

Daniel Roth visited a 100-year-old cemetery in his home city Basel. Walking among the graves he imagined invisible spaces, as if a subterranean labyrinth lay beneath the tombstones. For Leidsche Rijn, Roth has developed a chain of 'anonymous monuments' that refer directly to the journey made by Daniel 25 (the character from Houellebecq's novel) and to the remains of an earlier civilization. On their walk through the park, visitors come across groups of stones cast in bronze. Centuries-old tombstones are used for the production of these monuments, which are cast and treated in such a way that 'melted' openings are created. This gives the work a somewhat science-fiction appearance. The eight monuments appear in quiet areas of the park, where they will eventually become overgrown.

Zilvinas Landzbergas based his design
for Leidsche Rijn on a map of a city and
the activities that take place there. The
design is tailored to the Lelievijver (lily
pond) and constitutes a large water
basin with a fountain. The polished
interior of the basin reflects the water
surface and creates an interplay of
water and light. The exterior of the basin
is rough and unfinished. Little streams
ripple along and empty into the pond. A
dream-like and unreal underwater world
is created.

61

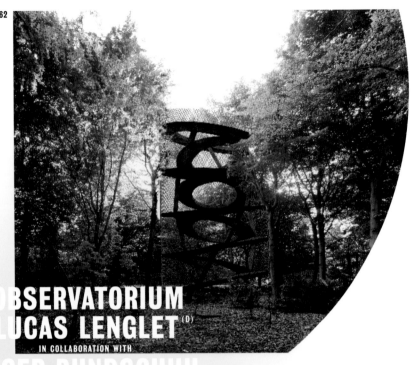

OBSERVATORIUM
LUCAS LENGLET (D)
IN COLLABORATION WITH
ROGER BUNDSCHUH
ARCHITEKTEN (D)
2009

Beyond invited three artists to make a design for an artwork in the playground of the Binnenhof: Darko Fritz (*200 OK*), Patrick Tuttofuoco (*Somewhere*) and Lucas Lenglet (*Observatorium*). Residents of Leidsche Rijn were asked to decide which of the designs would be realized. The design by Lucas Lenglet was chosen: a tall watchtower, built out of interlinked twisting circles. In the tower you can walk continuously until the path brings you out above the (future) trees. The exterior is wrapped in steel netting, which, in the long term, will become overgrown with climbing plants.

UNREALIZED PROJECTS

Das Organ
Gelatin [A]
2002

The Gelatin artists' collective from Vienna designed a 'speaker's corner' as part of the Action Research programme. The design includes a small soundproof hut with a 19m-high mast next to it equipped with loudspeakers. The hut has a homely interior in order to put visitors at their ease and encourage them to sing, recite a poem, unburden themselves in front of an erected microphone. All these forms of expression can then be heard for as far as the eye can see. Gelatine sees *Das Organ* as an extension of the human body and its fragile structure as an antidote to the over-planned built environment. Its design, however, was not considered feasible for building due to technical and monitoring reasons and also because of strict regulations governing noise pollution.

Handstand
Milohnic & Paschke [D]
2002–2003

The artist duo Milohnic & Paschke were one of the first to be invited to make an intervention in Leidsche Rijn in the framework of the Action Research programme. Leidsche Rijn was then still a sand flat with heavy construction traffic. It was inhospitable. But the area, with industrious workers among piles of gravel and building materials, also conjures the image of a pleasant sand box. The artists wanted to make a life-sized excavator do a handstand on its bucket. As if this concerned some *landmark* for 'Work in progress'. The piece plays with gravity, with the possibility of it falling, starting to spin or excavate again. *Handstand* captures the vitality of this huge new housing project in a single moment. The original plan was to carry out a temporary, swift intervention in addition to the already started *parasite* project of Milohnic & Paschke. The idea for *Handstand* proved to be unsuitable and too expensive for that.

63

Wapla
2003, Leidsche Rijn

Participants: **Barend Koolhaas, Marcel Smink, Bureau Dolte, Frank de Bruijn, Hans Eneman, Kaptein Roodnat, Marcel Schmalgemeijer, BAR Architecten**.

An environmentally friendly drainage system has been developed for Leidsche Rijn, in which the rainwater sinks into the soil instead of running off via the sewerage system. Because washing cars causes soil contamination, it was decided to create special car wash areas where the dirty water is collected.

In cooperation with Bureau Venhuizen and Property Development Leidsche Rijn, Beyond proposed that eight artists produce a design for an unusual car wash (Wapla) in Leidsche Rijn. This would make the Wapla into a very useful facility and a site that is eye-catching, that sticks in the memory, and that cannot be missed.

Eight designs were made and presented to a study group of people involved, at the beginning of September 2003. Both the industry union and the future users and clients (represented by the neighbourhood council Leidsche Rijn) comprehensively evaluated the designs and found them feasible. The designs are illustrated in the 'WAPLA sales catalogue', which was offered to potential car wash operators in Leidsche Rijn in autumn of 2003. The designs were received with great enthusiasm, but the operating companies did not dare to take the risk. They expected that the income would not be sufficient to cover all the execution and development costs of these very special Waplas.

Proposal for a House
Adam Kalkin [VS]
2004

After visiting the Leidsche Rijn area as part of the Action Research programme, Adam Kalkin submitted several proposals: so-called *Things* or interrelated interventions. He felt that decent Leidsche Rijn was more a 'state of outcomes and intentions than a place' and actually needed 'a kick up the backside'. Thus, he wanted to have a living mouse Stuart Little sailing the waterways of the Leidsche Rijn on a small boat. He also proposed that with all the deeds issued for Leidsche Rijn, female property owners should have the right to carry Adam Kalkin's child. Kalkin, if the DNA has been well disseminated, could then become town father by around 2050. He also submitted a design for a vegetable house, covered with fertile soil from Leidsche Rijn in which fruit and vegetables can be cultivated.

The interventions Kalkin proposed were seen as 'unfeasible', although the vegetable house was further investigated. However, the plot of land once assigned for this was no longer available due to it currently being an 'environmental circle'.

Artwork for a Noise Barrier
Guillaume Leblon [F]
2005, Veldhuizen

In the summer of 2005 the French artist
Guillaume Leblon participated in the
exhibition 'Pursuit of Happiness'. As a
result of his contribution to this – an
artificial-type landscape – he was
commissioned to design a work linked to
the noise barrier in Veldhuizen. Leblon is
fascinated by the way people mould
nature to their will, by the
materialization of time and by a
systematic manner of working. These
aspects came to the fore in his proposal
for Leidsche Rijn. Leblon wanted to have
a 15-m-wide strip of mud oozing from
the top of the barrier to the bottom.
Under the influence of an immense
'African style firework', this stream of
mud would be fired on its way to the
bottom – a process that would take
between three and four days. Due to the
particular composition of the mud – a
mix of concrete and clay – the stream
would then harden. What finally
remained would be a ceramic trail, a
reminder of the force of the fire from
'the burning days'.

The plan was enthusiastically
received. There was much appreciation
for the combination of land type art and
a performance of several days. But
many questions arose about its technical
execution and the durability of the final
art work. Could such a stream also have
the function of an artificial rock, be an
accessible 'nature reserve'? Leblon
could not offer enough assurance on
these points and for this reason the
imaginative but risky plan was
abandoned.

Onderspoor (sketch plan)
NL Architects (Kamiel Klaasse)

The railway embankment that runs from
Utrecht in the direction of The Hague /
Rotterdam cuts straight through
Leidsche Rijn. As part of Utrecht's urban
expansion, the embankment will be
widened and raised, and the track will
be doubled. The first new railway station
opened in Terwijde in 2004.

A total of fifteen tunnels will go
through the embankment and form the
connection between the north and south
of Leidsche Rijn. Because the tunnels
will, therefore, be an important daily
connecting point between the
neighbourhoods of Leidsche Rijn,
Beyond has commissioned a study-
assignment into ways of livening up the
tunnels. Architect Kamiel Klaasse of .NL
Architects (Amsterdam) made a design
for a modular wall system for eight of
these tunnels. In this plan the tunnels
were transformed into autonomous,
active zones in which anything could
happen. The modular system could be
used in all possible ways for (video)
projections; it could have cavities and
bulges, display cases and seating areas,
or podia. Even the possibility of an
interior skate ramp was under
consideration. The design was presented
to Prorail and Holland Rail Consult, two
of the contractors for the track
widening, and if approved would have
been included in the plans. But,
ultimately, the project fell through due to
the complex nature of the joint venture
and tightness of the budget.

LOTTE HAAGSMA

64

INTERACTIVE ADVENTURE

THE RECEPTION OF BEYOND IN LEIDSCHE RIJN

In 2006, the central embankment of a temporary roundabout on the outskirts of the new borough of Leidsche Rijn acquired a curious group of sculptures. Put together by the German artist Manfred Pernice, the handful of bronze statues looked rather out of place in this messy no-man's-land between the old and the new city. The traffic wound its way around them. *Roulette* is the title of this art project, which is set to run for several years. Every six months, Pernice selects some sculptures from Utrecht city's public art collection to make a new composition in the middle of the roundabout. The sculptures are removed from their original bases and taken to Leidsche Rijn. Empty spaces gape in Utrecht's parks and squares.

Many stories come together in *Roulette* : the continuous movement generated by city life, the relation between city and periphery, the visual impact of artworks in squares and streets, and the ties that people forge with these silent companions. For while art in the public space sometimes provokes aversion, it also generates feelings of deep affection. Some of Utrecht's townspeople are distressed to discover that 'their' statues have been spirited away to the Leidsche Rijn roundabout. The East Tuindorp neighbourhood committee protested vehemently against the removal of *The Good Samaritan* – a statue by Piet Esser that serves as the neighbourhood's emblem, adorning the local newspaper and business cards.[1]

In the art world, Pernice's work is seen as an exciting manipulation of the effect of art in public space. A subtle and successful concept, is the verdict of Sandra Spijkerman in the daily newspaper *Trouw*.[2] And Domeniek Ruyters, writing in the Dutch art magazine *Metropolis M*, described the project as 'an attempt of great artistic complexity to fathom the rules for the function of monumental sculpture in society'.[3]

1 Eddy Steenvoorden, 'Geen Samaritaan op de rotonde!', *AD Utrechts Nieuwsblad*, 7 March 2006.
2 Sandra Spijkerman, 'De misvatting rotonde = kunst', *Trouw*, 14 June 2008.
3 Domeniek Ruyters, 'Regels voor het sculpturenpark', *Metropolis M*, 5 (2008), 50.

Pernice's *Roulette* project was commissioned as part of Leidsche Rijn's art programme Beyond. The underlying scenario describes the programme as a 'strategic action plan' devised to explore the conceivable patterns of relationships between landscape, architectural programme and art'.[4] Instead of tamely conforming to the given built environment, art will play an exploratory and initiating role, from an early stage ○ while construction work is in progress ○ in the development of a new urban district. As part of this process, Beyond seeks to bring together recent trends in society and the visual arts in the public domain.

Mobile Architecture

The scenario posited several strategies for dynamic action geared towards attaining the above objectives. One was to install *parasites*: small-scale, lightweight and portable structures that could serve as seedbeds for 'new forms of urban living and new kinds of communities'.[5] Beyond introduced structures of this kind in Leidsche Rijn in 2003, with its event *Parasite Paradise.* Although *parasite* appeared in many places around the turn of this century – from the apple-green little building by Korteknie Stuhlmacher Architects that perched on the roof of Las Palmas warehouse during Rotterdam Cultural Capital 2001 to SKOR's exhibition of 'Mobile Architecture' on Stork's grounds in Amsterdam that same year – the 25 examples of work by artists and architects assembled by Beyond provided a large and highly differentiated survey of this ultra-light form of architecture. The open-air exhibition therefore generated immense interest and publicity. In a column in the architectural trade newspaper *Cobouw*, Piet Vollaard urged his readers to visit it: 'Virtually all recent classical solutions to nomadic, self-sufficient, light and recycled living, from the Netherlands and elsewhere, can be admired here in one place.'[6] And local newspapers enthused, with considerable relief: 'Finally, somewhere to eat and drink in

4 Bernard Colenbrander, 'Beyond – Leidsche Rijn.
 De *VINEX*-Assignment for Art', (Utrecht, 2001), 4.
5 Ibid., 6.
6 Piet Vollaard, 'Vakantiewonen', *Cobouw*, 19 August
 2003, 7.

Leidsche Rijn.' For the mobile village has numerous facilities that are yet to materialize in the new housing development, such as a restaurant, bar, cinema and theatre. Although the tables and terraces initially attracted fewer locals than had been hoped, the people of Leidsche Rijn have gradually taken to the charming little site on the outskirts of their district.

The project has also attracted criticism. The idea of placing the *parasites* at a safe distance from the residential estates, 'like a harmless enclave, behind railings', as Anne van Driel wrote in the national daily newspaper *de Volkskrant* elicited a sharp response from her and other reviewers.[7] As did the rather classical layout by Belgian architect Luc Deleu. Is this really the way to inject a bit of disruptive dynamism into an urban neighbourhood? Deleu has neatly grouped the mobile structures along a main street and a central square, with a farm, a campground and a lake at the periphery. Petra Brouwer, writing in *De Witte Raaf* calls the project an amusement park: 'The plan seems to have been lifted directly from Disney World: Main Street is the most universal small-town street in the world.'[8] In short, for all the enthusiasm it has generated, the experiment's critical potential is disputed. Even so, writes Linda Vlassenrood in *Architectuur Lokaal*, by engineering a confrontation between mobile, flexible architecture and new housing estates, the project is 'a good attempt, in all its contradictions, to escape from the Netherlands' regulatory straitjacket'.[9]

The project was certainly not devised as a one-off attraction. For two *parasites – Nomads in Residence/No. 19* by Bik Van der Pol and Korteknie Stuhlmacher Architects and *The Parasol* by Milohnic & Paschke – the exhibition was just the beginning of a long sojourn in the district. *Nomads in Residence* has become a visitors' centre for

7 Anne van Driel, 'Parasiet naast het nieuwbouwparadijs', *de Volkskrant*, 7 August 2003.
8 Petra Brouwer, 'Parasite Paradise', *De Witte Raaf*, 105, (September—October 2003).
9 The quotation comes from Linda Vlassenrood, 'Parasite Paradise. Pleidooi voor tijdelijke architectuur en flexibele woningbouw', *Architectuur Lokaal*, 42 (November 2003), 23.

artists who come and work in Leidsche Rijn for a while at the invitation of Beyond, while *The Parasol* serves as a temporary local meeting-place for the neighbourhood of Terwijde. And more *parasites* soon followed, like the *Paper Dome* by Japanese architect Shigeru Ban, a large dome-shaped pavilion that was installed immediately after 'Parasite Paradise' on the designated future site of Leidsche Rijn's town centre.

From Hardware to Software

With its 2005 exhibition *Pursuit of Happiness,* Beyond explored the well-being of people in their new living environment. 'From hardware to software' is how the programme's artistic team referred to this transition. From projects that were primarily devised as reactions to the physical and spatial parameters of Leidsche Rijn to artworks highlighting social themes, focusing on the local people and their dreams, desires and ideals.

Ten artists were invited to create artworks about the effort to achieve happiness, by way of artistic response to the neighbourhood. The darling of public and media alike was Erik van Lieshout, whose video lament *UP!* presents a highly personal, compelling account of his own arduous quest for happiness. There is also a large video programme with work by artists including Santiago Sierra, Marijke Warmerdam, Anri Sala, Querine Racké and Helena Muskens, challenging the blissful ideal of the sparkling new estate and confronting viewers with the instinct for self-preservation in the lower reaches of society.

While most of the artists participating in *Pursuit of Happiness* preserved a certain distance from Leidsche Rijn and the people living there, the Turkish artist Esra Ersen actively sought the locals out. She dressed a group of loitering youths in macho leather jackets printed with messages they chose themselves. Immediately after the opening, the jackets were stolen from the exhibition. Perhaps it was a fitting conclusion to the interactive adventure of this artwork, but it did not do the youths concerned any good. There

was talk of rival gangs, and some people suspected the boys themselves. For all the artist's good intentions, the youths felt they had been stigmatized, depicted as a gang of young hoodlums. 'We're not a gang at all. We're just friends,' they told Inge van den Blink, when she interviewed them for the local newspaper, *Utrechts Nieuwsblad.*[10]

The item that attracted most critical and public acclaim was Stanley Brouwn's pavilion, which was completed shortly before the opening of 'Pursuit of Happiness' and opened at the same time. This work 'is not about happiness, it spreads happiness', wrote Bert Mebius in the journal *Tubelight.*[11] Bertus Mulder, the architect who translated Brouwn's concept for *The Building* into reality and whose previous projects included the restoration of the Rietveld-Schröder House, said in an interview for the *Volkskrant*: 'The technology needed to build it did not exist at the time. But Rietveld would have loved to build this house.'[12] Frank Hemeltjen writes on the website ArchiNed that as an architect, too, this publicity-shy artist shows himself to be 'a real Houdini'. He continues: 'The maker is actually invisible but as director and guide he nonetheless has the most prominent role. Visitors experience here, in a nutshell, the location, the setting, the remote background view, and consequently the idea of distance.'[13]

Unsolicited Art that Disrupts

Over the years, Beyond's approach to art in the public space in Leidsche Rijn has attracted a great deal of international interest. Its staff welcomes guests from all parts of Europe and even America and have been invited to discuss their experiences in countries including Belgium, Germany, Italy, Poland and Switzerland. Beyond stands out internationally in several ways. First, in its dynamic

10 Inge van den Blink, 'Gaat het om de jassen of om ons', *AD Utrechts Nieuwsblad*, 16 September 2005.
11 Bert Mebius, 'Weet je wat mij wel goed lijkt? India!', *Tubelight*, 40 (September–October 2005), 12.
12 Rob Gollin, 'Eén Stanley Brouwn-voet is 26 centimeter', *de Volkskrant*, 25 August 2005.
13 Frank Hemeltjen, 'De verschijning van Stanley Brouwn', *ArchiNed*, accessed 2 December 2005.

structural organization, which enables it to respond flexibly to ongoing trends, and an office that has been funded to work on a cohesive programme for several years. Second, the sheer scale of the programme impresses people, along with the international selection of celebrated artists, who are allowed ample artistic freedom, with the office's support.

In Leidsche Rijn itself, however, here has been plenty of opposition. Disapproving responses appear in columns and letters to the editor. Some say that the art is obscure and often downright unintelligible; that Beyond panders to the taste of a national and international public of art lovers and takes too little account of the preferences of the local people. Furthermore, not all locals are happy about ambitious art projects being staged while they are still surrounded by expanses of sand and languishing without a decent infrastructure and basic facilities. In the words of one local visitor to 'Parasite Paradise': 'I understand perfectly well that the money comes from a different bit of the budget, but it still rankles. An artists' village is erected here at the speed of light and our houses are very well designed, but the local authority hasn't taken the trouble to sow a bit of grass seed to stop the sand blowing about our streets all the time.'[14]

Around the time that the exhibition 'Pursuit of Happiness' was reaping acclaim in the art world, the criticism levelled at Beyond in Utrecht and Leidsche Rijn rose to new heights. The local authority's threat to make drastic cuts in its grants for the amateur arts in Leidsche Rijn provoked widespread indignation, with many pointing out that the authority had spent 3.5 million euros on Beyond.[15] And for that sum, the people of Leidsche Rijn get 'unsolicited art that challenges, interrogates and disrupts', writes the poet Ingmar Heytze in a column for the *Utrechts Nieuwsblad,* where they would have preferred 'culture that forges ties between people'.[16] Some

14 Inge van den Blink en Anka van Voorthuijsen, 'Van apekool tot dolle dromen', *Utrechts Nieuwsblad,* 23 August 2003.
15 Wouter de Heus, 'Gemeenteraad opent wederom aanval op ruimgevulde Beyond-kas', *Ons Leidsche Rijn,* 26 October 2005, 2.

members of the city council suggested taking another look at Beyond's budget.

All's well that ends well: the row led the lawmakers to scrap the planned cuts. The umbrella organization Cultuur 19 was able to continue its programme of courses, festivals and performances – including Shigeru Ban's *Paper Dome*, one of Beyond's initiatives. The budget allocated to Beyond was also left intact. All existing plans were able to go ahead.

Even so, there was a perceptible change of atmosphere. Not that Beyond reined in its aspirations: its international orientation was undiminished and it continued to work with celebrated artists – such as the internationally acclaimed Dominique Gonzalez-Foerster, who created the twin *parasites Sainte Bazeille* in 2006. But from then on, frequent efforts were made to involve the people of Leidsche Rijn directly in the process. In the project 'House for Sale' that same year, the public were invited to choose their favourite from three designs for an artists' house. The winner was *The Castle*, by Hans Aarsman and Erik Kessels, a 'safe house' for freedom of expression. Also in 2006, Silke Wagner and Sebastian Stöhrer proclaimed the motto 'Everyone is an expert', and invited the residents of Leidsche Rijn to share their abilities and expertise with their neighbours. *Nomads in Residence/No. 19* served as a venue for salsa classes, performances by local musicians, workshops on how to make didgeridoos, and mandala drawing classes.

A year later, the British artist Sophie Hope achieved great success with her community art project 'The Reservation'. In a simple but ingenious reversal, she invited residents to reflect on their own lives. How would the people of 3007 respond to the estates that had been built in 2007? What elements that we take so much for granted will elicit astonishment from remote future generations when their remains are excavated? This archaeology of the future was devised with and for the people of Leidsche Rijn. Hope roused interest by contacting schools, organizations and individual local inhabitants, after which the participants fleshed out

Lotte Haagsma

16 Ingmar Heytze, 'Containerkunst', *AD Utrechts Nieuwsblad*, 21 November 2005.

her concept together. On the day of the performance, some 80 volunteers were busy ensuring the play's success. Over a thousand people came to see 'The Reservation', most of them from Leidsche Rijn. The reports of the day's cheerful activities in local newspapers were accompanied by numerous photographs.

Placemaking

According to the plans, the new generation of Dutch housing estates would not be the latest in a long line of dormitory towns, but compact, lively communities with close links to the old city, designed according to urban development plans that would take account of local history and would include diverse types of architecture. This was how the people who wrote the Supplement to the Fourth Policy Document on Spatial Planning, dubbed 'VINEX', saw the housing estates of the future, which came to be known as Vinex estates. As so often happens, the reality was rather different. Most Vinex districts have evolved into mono-functional residential areas.[17] One block after another of terraced housing meets the eye – and the vast new district that is now growing alongside the old city of Utrecht is no exception. That does not make it easy for artists to find themes on which to build their work, particularly in the early stages, when the first residents are moving into their houses and the landscape is dominated by expanses of sand. 'Something of a ghost town', is the way the artists' duo Wagner and Stöhrer see Leidsche Rijn in the daytime, when most of the residents have left for work.[18] 'There is no here there. There is no there here', is how Adam Kalkin expressed the lack of context, the sense of a tabula rasa he experienced here.[19]

Even so, Beyond has helped to create, and inject life into, a public space in Leidsche Rijn. The temporary pavilions play an important part here. The *Paper Dome* and *The Building* are used

17 Jelte Boeijenga en Jeroen Mensink, *Vinex Atlas* (Rotterdam: Uitgeverij 010, 2008), 43.
18 Joëlle Poortvliet, 'Parasites in Leidsche Rijn', *AD Utrechts Nieuwsblad* 29 June 2006.
19 Inge van den Blink, 'De stad Utrecht is hier ver te zoeken', *Utrechts Nieuwsblad*, 4 November 2004.

intensively. They serve as venues for concerts, evening debates, workshops, festivities and exhibitions, some of them organized by Beyond, but most by others. Today, few remember that these places arose from Beyond initiatives. The people of Leidsche Rijn have appropriated the pavilions – one could hardly hope for a bigger compliment.

At the same time, Nomads in Residence/No. 19 has served as a base for many artists over the years, and is used on occasion as a stage for artworks – some of which take the form of meetings and exchanges. Here Beyond has responded to the growing tendency since the 1990s for art in the public domain to engage expressly with social themes. This art no longer stands about in meek silence in parks while life rushes on around it. Artworks engage, communicate, and rouse; they get down from their pedestals, or in some cases actually become the pedestal, transmitting and feeding experience.

Beyond's most significant contribution to Leidsche Rijn, perhaps, has been in the sphere of 'placemaking' – a term used by designers and sociologists for the development, through social processes, from an abstract physical space to a place that resonates with experience – by staging unusual events in frequently still vacant sites amid a sea of residential housing.

The day is gradually approaching on which Beyond will bring its programme to an end. That does not mean the end of art in Leidsche Rijn. Others will carry the torch, and although most of its projects have been temporary, Beyond will leave traces of its activities. In September 2009 the art programme will conclude with the installation of seven permanent statues in the future Leidsche Rijn Park. Six were selected by Beyond's artistic team. The seventh was chosen by the people of Leidsche Rijn: a 14m-high observatory designed by Lucas Lenglet from which the park's visitors will be able to survey the surrounding area. Perhaps their gaze will take in *The Building* by Stanley Brouwn. At the moment the pavilion's pure, magical contours mark the entrance to the district, but once the building of Leidsche Rijn's new town centre is underway, it will be

moved – hopefully to an equally prominent new location. For this work by one of the greatest masters of Dutch conceptual art has gradually become etched into the community's collective memory. Like East Tuindorp's *Good Samaritan, The Building* has all the ingredients of a logo.

BEYOND LEIDSCHE RIJN

THE VINEX ASSIGNMENT FOR ART

For each project there is a beyond,
a domain where no jury will follow
Rem Koolhaas - S,M,L,XL

SCENARIO BEYOND

JANUARY 2001

BEYOND - Leidsche Rijn
The Vinex Assignment for Art

For each project there is a beyond,
a domain where no jury will follow
Rem Koolhaas - S,M,L,XL

I INTRODUCTION

The Second Creative Impulse

In 1995 the Leidsche Rijn Master Plan was completed.
With this, one of the most extensive building projects
currently in the Netherlands could begin. The Master
Plan, supplemented by the Development Vision for
Leidsche Rijn and the Structural Sketch for Vleuten
and De Meern in 1997, did not simply amount to the
umpteenth plan for the umpteenth *Vinex** location,
but was instead a striking moment in the evolution of
Dutch urban development.

Here the boundaries of the professional field are being
pushed back, and a new harmony is being sought
between an old discipline and the social realities of
today. Furthermore, the redevelopment of the former
western grasslands is a drastic new step in the urban
development of Utrecht. The city was once enclosed
by a compact contour, sharply contrasting against the
relatively empty surrounding countryside, but gradually
the orderly form has taken on spacious and facetted
dimensions.

With the arrival of Leidsche Rijn, Utrecht definitively
becomes a diversely composed 'urban field', a city
in the region, a dynamic component of the Delta
Metropolis Randstad Holland. In the neighbouring
area, it encounters other villages with which a new
understanding is developed. The polarized relationship
between the historical city centre and the formerly
eccentrically situated village communities has
developed into a cultural and spatial diversity within
a single urban context. An important overture to these
developments is the recent administrative merger
between the councils of Vleuten and De Meern, which
confirms that, particularly now, the broad perspective
of the urban field has a real chance of success.

Five years after the compressed ideas of the Master
Plan, the moment has come to release a second,
potentially just as significant impulse into the building
location, and to begin the plans for the visual arts
in the area. How should we approach art here? The
initial situation is thought provoking and rich in
opportunities. To start with, there are local points of
departure for an art programme: the history of a site,
with all the associated cultural-historical realia, and the

drastic changes that the landscape undergoes when
urban development rapidly 'descends' upon it. But
the view of what art could mean to Leidsche Rijn
has also come into focus due to broader cultural and
political developments.

An unmistakable trend can be observed in culture
towards the multidisciplinary, and a broadening of
the formal and intrinsic purpose of art, at the cost of
the classical autonomy of the work of art. This was
illustrated in Documenta X, held in Kassel in 1997,
where art was mixed with social commentary, with
politics and with spatial planning. Architects and
photographers shone here perhaps brighter than
the artists. Although the artistic community that the
manifestation brought together was not speaking in
unison, the outlines of a new pluralism were evident.
Interestingly enough this pluralism seems to have
shaken off the postmodern coquetry with chaos and
incoherence, in favour of a renewed engagement with
the manipulability of the social reality.

In architecture too, putting the independent value
of 'the object' into perspective has become a theme.
It was no coincidence that during the Venice
Architecture Biennale in the summer of 2000,
aesthetics as a subject of interest was flamboyantly
exchanged for ethics, however much the adoption
of such a term by architects should, by the way, be
distrusted. The question of design viewed separately
is now apparently deemed subordinate to the
question of the underlying programme. Today's
culture is not about beautiful things but about
motives, about ideas and the exchange thereof, and
about accessibility for the stranger.

Art looks at architecture, architecture looks at
art, and they both look at the world around them.
The world lies open, more than ever, factually *and*
virtually. The culture policy is following this trend
closely by advocating the merging of interests,
where previously separate territory was profiled.
On a national level this has a bearing on, among
other things, the relationship between historical
heritage and the culture of the future. With the
implementation of the Belvedère Memorandum
(Nota Belvedère) the position of the cultural heritage
will be highlighted in a new, more dynamic way in
relation to the spatial changes. Old and new are seen
less as individual glories, more as qualities in an

intense interaction. The government is also currently advancing other cultural interactions.

Thus, the policy of the Ministry of Education, Cultural Affairs, and Science (OC&W) is explicitly aimed at integrating the work of artists with that of architects and planners.

When the meaning of the cultural action is found more important than the form of 'the object' in isolation, it also goes without saying that the practice of art methodically remoulds itself. This applies to the way in which individual artists and architects tackle their work, and is faithfully reflected in the culture policy. An obvious trend in contemporary spatial planning is that the intentions and components of spatial design appear to be less hermetic, and so become receptive to unanticipated signals from outside. With the recent appearance of the Fifth Memorandum on Spatial Planning (Vijfde Nota over de Ruimtelijke Ordening), a less cumbersome, more realistic planning apparatus than that at present is being sought, with more local variation and more opportunities for decentralized, private initiative.

Made-to-measure work must originate on location, under the supervisory eye of higher administrative layers, but particularly it must be fabricated from the bottom up. Society can still be affected by government policies, but classical top down notions have been abandoned.

This is the culture of today, indisputably adrift, and art adapts itself both intrinsically and methodically. This scenario forges the observed trends into a strategic plan of action. However differentiated its components may be, this plan does set out a clear line: it is concerned with exploring the conceivable relationship models between landscape, building programme and art. The activities and projects are given a name, complete with accompanying strategy to turn ideas into reality. A concept of finalization, fixed in time and space, is not under discussion here: this is no 'blueprint' plan, but a plan of which the precise form will only become definite during the implementation. Thus far, the message of the Development Vision, after four years in which the elasticity of the plan was fully stretched by way of a 'well-being coefficient', has been well received.

Contours of a Scenario

In order to connect directly with the intentions, opportunities, and impossibilities of the Development Vision, it is necessary to jump aboard the moving train of the building projects as soon as possible. This is essential because the scenario regards the autonomous problems of visual art as subordinate to the cultural issues that play a role in today's society.

Building on this ambition, the assignment must be formulated using the following strategic questions: **What are the social developments concerning the public domain, specifically that of Leidsche Rijn? How do these developments relate to tendencies in art? How might this bring about a shift of emphasis in the practice of visual art? How can art contribute, intrinsically and materially, to the discourse on the contents of the public domain?**

Beyond starts with these questions – which can be further refined into a three-part critical research assignment for the visual arts:
– Firstly, base the art project on an evaluation of the characteristics of Leidsche Rijn as a contemporary development project in spatial order;
– Secondly, develop ideas for this location that demonstrate a critical reflection on the conventions of the current building programme;
– Thirdly, make themes of questions relating to spatial development and art that ideally go beyond the borders of the project area, and that are concerned with the occupation of space: the practical usage of space, the meaning of living and working in Leidsche Rijn, and the meaning of the relationship with the natural and cultural environments.

In this way the programme for Beyond is founded on an interesting collection of subjects for art to overcome. There is the question of spatial behaviour as a universal human activity, theoretically linked to the earliest and most primitive forms of settlement in a primal landscape. There is also the question of spatial development as a specific cultural intervention. In the concrete situation of Leidsche Rijn this basis primarily implies an explanation of the ramified concept of urbanism. How can the meaning of this concept be represented schematically?

Urbanism amounts to a *programme*, an arrangement of functions that are deposited in a more or less streamlined form in the space. Beyond is aimed at exploring the range of such a programme. An urban community exists independently of the land and is a contraction, a melting pot of culture: this implies an unavoidable variation of lifestyles, customs and habits. And a suitable community for this – however determined the occasional attempts to thwart it have been, through planning regimes or simmering resentment – is preferably one that is open to the unexpected, one that promotes encounter and recognition between people, and that accepts newcomers and opens its own community to outside influences.

With these added specifications the city can become a spawning ground for culture and social and

economic innovation. At the same time, and just as dramatically, it is a house of mourning for obsolete culture.

Spawning ground – house of mourning: the town manoeuvres between these two functions with a slightly different balance in each case. The urban forming of Leidsche Rijn is conducted in an atmosphere of intense social dynamics, in which the first impression is that more is being spawned than laid to rest, an atmosphere that shapes suburbs just as easily and quickly as the Disneyfication of town centres. The latter definitely belongs to the mausoleum rather than the delivery room. With the art of Leidsche Rijn an impression can be made on the process of urbanizing the outskirts. The spatial culture of suburbia, and the customs and habits of the residents who have settled there, are the subjects.

Beyond aspires to contribute to the many-sided definition of what *urbanism* entails: in the explanation of this, an autonomous corpus of purely contemporary trends in human behaviour is the very least that can be discerned. Human nature dictates that the urban programme is also partly formed out of the *conventions* of urbanism, built up through millennia of urban civilization. These conventions are somewhat general in nature: archetypes of urbanization have been circulating since ancient times, constantly adapted and adjusted to the period. Just as Rome was, for centuries, an inexhaustible source for the typological trappings of the city, other idealized urban models also progressed in this way: Amsterdam's concentric canals remain a reference and that also applies to Haussmann's Paris and more recently to Manhattan.

Urbanism regularly relies on archetypal conventions but is just as often determined by local factors: the historical morphology of a city is sure to provide an explanation for its appearance and structure. In keeping with this, an alloy of programmatic points of departure and conventions will underpin the new Leidsche Rijn. The large-scale building programme of the *Vinex* policy finds itself in the local morphological reality of a river drainage basin and an embedded local order. That order remains recognizable here and there, in the patterns of the plots of land and in cultural-historical relics, but it is also forced to combine with the equally archetypal qualities of Dutch suburbia.

Is there more possible? Can Leidsche Rijn work its way up to become a genuine metropolis, if the spirits so decide? Yes, it is conceivable, as long as the qualities of a metropolis do not necessarily have to equal the classical examples from ancient and modern history. A metropolis does not need

to include the congestion of Manhattan, the chaos of Mexico City, or the social catastrophe of Rio de Janeiro.

The Dutch metropolis is on its way in the area we have come to know as the Randstad. It is based on a highly urbanized initial situation of infrastructure and occupation. But the metropolis in this mouldable land is primarily a magnetizing design undertaking that can be anchored in the variation of the landscape's qualities, in programmatic differentiation, in the articulation of building density (from very high to very low), and in prominent relationships between old and new. These are the themes that are emphatically under discussion in Utrecht due to the urbanization of Leidsche Rijn, namely, the way in which the old, concentric concept of urban planning has been exchanged for a more elastic city concept that ensures a full position for the characteristics of suburbia and of the old villages. The giant green heart of Leidsche Rijn gives the traditionally small-scale village centres a recognizable position in the new urban field, a position of authenticity in development. In Leidsche Rijn a new sort of urbanism is emerging, one in which lines of vision lead to the Dom Tower as well as to the village church in Vleuten.

Beyond intervenes in this urbanized landscape, situated in the middle of the Delta Metropolis Randstad Holland, and focuses on the ambitions of metropolitan development from an angle other than that traditionally used. This scenario firstly provides for the fabrication of an intrinsic foundation, through a number of essays intended to make the landscape and programme for Leidsche Rijn accessible. Moreover, the scenario postulates the idea of an open and transparent communication system for interaction with the public. This system is based on the opportunities offered by ICT, already an important, albeit mostly virtual, component of new urbanism. But the principle part of the scenario is composed of a number of approaches to the theme of urbanism by way of art projects, which are primarily related to the *nature* of the spatial assignment and the *dynamics* of the transformation of the area. The most promising ideas that have advanced are:

–An **Action Research** programme in which artists investigate Leidsche Rijn's potential by means of experiment and temporary interventions;
–The **integration** of artists' expertise into relevant urban design projects, for example, in relation to the positioning of infrastructure;
–A series of **Artists' Houses**, used as a means of researching the hardcore of suburbia and one of the most inalienable parts of human civilization (from primitive hut to bungalow);

–A *parasites* programme aimed at creating a breeding ground for new forms of urbanism and new forms of community;
–The striking contents of a series of **White Spots** on the map, where art expresses itself most fundamentally on the factors of time and space.

The plan for Terwijde, which is currently reaching a definitive design and will immediately be offered for sale in phases, will be used to test all these ideas in the near future.

II BEYOND – THE FOUNDATIONS

The Contents – Six Inspirational Essays

Six specialists were invited to share their vision of the larger social developments concerning the public domain in Leidsche Rijn, by writing an essay that can serve as a source of inspiration or information for the art programme in the public domain. These essays will be compiled, published and made available to the participating artists.

The first two essays deal with the material and natural bearer: with the morphology and ecology of the landscape. The third and fourth essays are intended as a social profile of the community on the ground: the geography of human behaviour. What sorts of people are populating Leidsche Rijn? Do they form a homogenous group whose behaviour and wishes are highly predictable? The third essay deals with a special aspect of the social order of Leidsche Rijn, namely the tension between the concrete geography of the sea of houses and the intrinsic, partly virtual network that the residents navigate in their daily lives. Finally, the fifth and sixth essays are particularly concerned with the spatial culture. The fifth essay analyses the design of the urban development in Leidsche Rijn, and places it in the tradition of Dutch planning. The last essay looks at ways in which Leidsche Rijn could become a work terrain for the arts, whereby the line of approach is not focussed on the autonomous qualities of art, but on the relationships that can be forged with nature, in all the stratification of the term, through art. The contributing authors are Max Bruinsma, Bernard Colenbrander, Petran Kockelkoren, Paul Schnabel, Martin Reints and Cor Wagenaar.

Communication – A System for Interaction

One way in which the scenario is made truly effective and socially relevant is by dwelling extensively on its communicability and interactivity. The contents of Beyond must be communicated to the outside world and, conversely, the outside world must be able to affect its contents. In order to allow the latter to function smoothly, the communication strategy is an integral and essential part of the scenario and not a relatively unimportant addition created to solve a derived problem.

An open and transparent plan development, with a lot of outside influences, has been expressly chosen for this art project. Looping is the working name of the communication structure set up to achieve this. The structure is aimed predominantly at involving individuals rather than groups, whether organized or not, considering that the social reality is increasingly geared towards the fragmented character of the collective. Before the art projects are realized, Looping ensures that a communication and discussion process is initiated with a 'loop' connecting the public, producers and decision-makers. The loop is monitored by an editorial board consisting of members of the project team and external communication specialists: Jan van Grunsven, Mariette Dölle (project team) / T©H&M (design) / Max Bruinsma (external advisor).

For the time being, the editorial board is concentrating on the realization of four goals:
–developing support for Beyond among participants and interested parties both locally and non-locally;
–ensuring that the decision-making process, which ultimately leads to the awarding of commissions to artists and designers, is transparent and has the possibility for constructive *feedback* built-in;
–realizing a programme that will only acquire detail in the course of time and providing an 'instruction manual' for **Looping**, which does, after all, need to continue functioning after the project team withdraw from the initiation phase. This programme will span the entire duration of Beyond;
–harmonizing the specific aims of the art project with the established communication mechanism provided by Leidsche Rijn's department of communication, for example, by linking *websites*.

The editorial board is the pivotal point connecting all the data flows produced by the realization of the arts plan, between the planning organization and the public, and between the active participants in the *discourse* on the art of Leidsche Rijn. As an intensive means of communication between citizens, government, and the makers of art, **Looping** aspires to be an instrument of democracy.

A plan of action has already been completed for the communication programme. **Looping** will be functionally introduced with a plan of activities for 2001-2002, carefully attuned to the established communication programme that was initiated for the urban development of Leidsche Rijn. In the same period the main specific aspects of the **Looping** strategy will be tested in the Terwijde plan area.

III BEYOND – ART PROJECTS

The art projects of Beyond do not stand alone, but are fundamentally linked to the stratified 'intrinsic foundations' and to the **Looping**, both of which have already been outlined. In this way they are also fundamentally linked to the hard, and not so hard, facts concerning the location and the kind of life that is settling there. The art of Beyond establishes roots in the material (soil, landscape, archaeology), searches for connections with old and new culture, and subsequently allows itself to be dragged along in the unrelenting flow of time.

Action Research can be regarded as an overture: with a series of separate art actions, a new territory is being demarcated and structured in colour and form. This is followed by the conquest of the soil, surface and air space: the exploration of depth, height, length and width.

The second category, after **Action Research**, is concerned with art in urban design projects. This is about weaving ambitions together very precisely: about the integration of artistic intelligence, chiefly into the civil engineering design.

The next category of projects, the **Artists' Houses** define a fundamental vision of the fundamental human activity of living together.

In the fourth category, the *parasites*, an open exercise is postulated: the exploration of possible forms of occupation in an area that has not yet been entirely monopolized by a new set of functions.

Finally, **White Spots** define the conquest of the dimension time: art projects which are located on empty spaces in the evolving landscape, some of which will disappear when they are overtaken by the tentacles of the market.

The selection of the artists will begin after the conclusion of this scenario. This is why the references – collected with a pluralistic view and from different generations – only serve to clarify the rationale of the categories described; sufficiently to create a first impression of what Beyond is all about. In recent years, artists have already familiarized themselves with the way of thinking that forms the basis for this scenario. Nevertheless, the image that the references reflect is sure to be superseded during the implementation of this art plan by new, as yet unknown developments in the evolution of the artistic production.

A Action Research

A series of **Action Research** projects are intended to put art on the map of Leidsche Rijn in a short period of time, by way of a well orchestrated plan of action in which the new communication structure plays a full role in achieving the maximum reach. **Action Research** is about the variety of colours in art itself. Directly engaging with the topical themes of contemporary art and the challenge of a concrete building location, an **Action Research** project can be developed and launched acutely. The projects make it possible to draw the attention of the public to Beyond's ambitions from the outset. A small series of plans in this category is sufficient to be a conspicuous forerunner of what will follow. Art will regularly take possession of sites ahead of the arrival of the new town: the established procedural order of urban development followed by the application of art is deliberately reversed here. These are the methods of Beyond. In principle, the whole of Leidsche Rijn is the field of study for **Action Research**.

References:

a.1. Dennis Adams, Stadium (seating from Galgenwaard Stadium) for Leidsche Rijn, 2000
a.2. N55, Land ('hill project') for Leidsche Rijn, 1999
a.3. Jeanne van Heeswijk, Valley Vibes project, London,1998
a.4. Phantombüro, Hafenbad, Frankfurt, 1996
a.5. Otto Berchem, The Green Room in the Rijksacademie, Amsterdam, 1997
a.6. Ines den Rooijen, 100% Gratis, Maastricht, 1999
a.7. Jens Haaning, Sweatshop in the Vleeshal, Middleburg, 1997
a.8. Christian Jankowski, Schämkasten in the Appel, Amsterdam, 2000
a.9. Matthijs de Bruijne, Lissabon project, 2000
a.10. Lonnie van Brummelen and Quirijn Küchlein, project for Artoteek Oost, Amsterdam
a.11. Harmen de Hoop, Garderobe (various locations), 1994
a.12. André van Bergen, project with shower, Amsterdam,1998
a.13. David Hammons, Blizzard Ball Sale, New York, 1993

B Art in Urban Design Projects

When the automatic, universally adopted codes governing the form of the urban space fall away, a multidisciplinary method of work offers more opportunities than ever to solve complicated design problems. After all, good ideas on how to fill an empty public space, for a street layout, for the design of a railway line, do not necessarily stem from civil engineering. Some design projects are pre-eminently suited to allow a fresh view of an old problem. Artists can then offer a welcome contribution. In Terwijde, for example, investigations are under way to determine to what extent art can shed new light on the function of the tunnels in the railway embankment. In this way a cultural dimension is added to problems that are usually regarded as purely functional and technical questions. Apart from the railway zone, this integrated art utilization is also applied to locations such as the A2 motorway route and the so-called 'watercross' in the Amsterdam Rijn Canal near Park Voorn. In the latter example Beyond marginally exceeds the planning area of Leidsche Rijn: the bridge to the old city is being built.

References:

b.1. Ton Venhoeven and Aernout Mik, Jan Schaeferbrug, Amsterdam, 1997
b.2. Ton Venhoeven and Arno van der Mark, De Reeshof, Tilburg, ca. 2000
b.3. Luc Deleu, proposal for TGV Station Europa, Brussels, 1986-1989
b.4. John Körmeling, On A Scale, proposal for the A2, Amsterdam, 1988
b.5. Berend Strik and One architecture, expansion plan for Salzburg and beer pavilion, 1996
b.6. Remy Zaugg, two bridges and boulevard in Sonsbeek, Arnhem, 1993
b.7. Jan van Grunsven and Arno van der Mark, 301 STEPS (DAYLIGHT/TUNGSTEN), The Hague, 1998

C Artists' Houses

In urban architecture the newest manifestations of culture are mixed with the oldest conventions and archetypes. The town hall is the bearer of unalienable characteristics while at the same time being a testing ground for new discoveries in the field of living culture. Suburbia itself offers a rich breeding ground for both these extremes. Fundamentally this is always about designing the habitat, the mother of all architectural undertakings.

On the other hand, the issues of the day unavoidably resound in the recruiting methods used by property developers to interest people in their plots, and in the tastes that the residents display in their private paradises. The entire scale of architectural conception, from the sublime to the flashy, can be found in the suburban dwelling. Besides the definition of the collective domain, market forces primarily determine the quality of a *Vinex* location. The question is whether or not this offers the correct point of departure for a critical reflection on what the house has been, what it can be, and what it could become. This has led to an additional design project for the *Vinex* location Leidsche Rijn. A number of building plots have been reserved in the planning area for the development of this project. Commissions for houses on these plots are awarded to artists from whom productive insights into building and living can be expected. Beyond, camouflaged as an alternative property developer, mediates between potential designers and potential buyers of these made to measure houses. In this case, mediation should be interpreted in the extremely active meaning of the word. The entire area of Leidsche Rijn that has yet to be developed is, in fact, a possible site for **Artists' Houses**.

References:

c.1. John Körmeling, starting house at rowing course, Slochteren, 1992
c.2. Pjotr Müller, The Garden, Museum De Pont, Tilburg, 1994
c.3. Atelier van Lieshout, house and galerie Fons Welters, Amsterdam, 1993
c.4. Jan van de Pavert, House, ca. 1990-1995
c.5. Jorge Pardo, Pardo house, Los Angeles, 1998
c.6. Observatorium (André Dekker c.s.), Dwelling for seclusion, New York, 1997
c.7. Gerrit Rietveld, Rietveld-Schröder house, Utrecht, 1924
c.8. Thomas Schütte, Haus 4 (maquette), 1986
c.9. Jan van Grunsven, Architectural model no. 2b, Floriade 1992, Zoetermeer, 1992
c.10. Park & Schie 2.0, Autarkic House (in development),
c.11. Winy Maas and Arno van der Mark, Borneo island dwelling, Amsterdam, 2000
c.12. Christian Rapp, dwelling Santen / dwelling De Vroom, Borneo island, Amsterdam, 2000

D Parasites

'Parasites' is a collective term for experimental light urban development, and stands for residential or professional spaces that require a minimum of facilities, are movable, and that serve as a means of exploring new forms of occupation in an uninhabited, or rather, not yet urbanized area. For this project Beyond engages literally with the physical and social problems facing a new community in a recently occupied area.

Parasites are about pioneering, about exploring the concept 'city' in form and function with artists in the role of propagator. They become engaged with what they encounter, they adapt, they even build, they test their own resistance – and eventually they alter course again, or not.

The results of their efforts must not be determined beforehand in a programme or form: the intention is not to create a series of eccentric pavilions. The intention is to provide a podium for the unsolicited, generated by 'life itself' but expressed in the vocabulary of art. This does not automatically reduce the *parasites* project to chaos. It is true that new forms of urbanism in our time have invariably had a hyper-individualistic background but this can be recognized early and attuned to other phenomena and artefacts in the space. This is why a programme controller or an editorial board should supervise the creation of the *parasites*, in order to produce custom-made items in a complex, unavoidably fragmented artistic programme. Opportunities for *parasites* lie particularly in places that have been put on hold as it were, waiting for a future programme to descend. This could include places such as the zones not yet suitable for development near the railway line and the slope to the side of Veldhuizen.

References:

d.1. Atelier van Lieshout, AVL-Ville, Rotterdam, ca. 2000
d.2. Krijn Giezen, Heating in Polderpark Cronesteijn, Leiden, 1994
d.3. Robert Jasper Grootveld, floating island, Amsterdam,
d.4. Alicia Framis, Loneliness in the City, Dordrecht, Barcelona, Munchengladbach, Zurich, and others, 1999-2000
d.5. Karen Lancel, Agoraphobia, various locations, Amsterdam, 1999-2001
d.6. Constant, New Babylon, 1959-1974
d.7. John Körmeling, pavilion at transformer house/sewerage pumping station Markendaalse Weg, Breda, 1988
d.8. Hans Venhuizen, Amphibian Living, 2000

E White Spots

The growth of a city can normally be expressed in more or less organic patterns, which show how buildings are added from a certain morphological point of departure, in a succession of, usually, abrupt phases. Leidsche Rijn is no exception to this, along with almost all the development plans from modern times it shares the characteristic that the rate of growth has accelerated to such an extent that we should in fact be speaking of a city's expansion in a single move outwards. And yet, even in this tightly drilled process, a timeline can be discerned. Construction is already underway at some sites and will start at others in due time, while in some zones the first stake will only be driven into the ground when the investment pressure is high enough. A phased construction implies the presence of scattered spots that are currently empty, but where something is expected at some point in the future. This is where art settles for as long as it can: art occupies the space with a directed intervention, explicitly intended as a temporary investment in the exploration of spatial possibilities, which will disappear again when the time for architecture arrives.

The **White Spots** will be used for art that is, in as concrete terms as possible, grafted onto the factors of *time* and *place*. This also refers to places that seem to have detached themselves from the calendar's regime: for example, art can be used to reveal the untouchable cultural-historical cores in the landscape, the status of which is not always evident. Together, the **White Spots** form a meaningful series of dots on the map, each with its own temporal and spatial significance. While the *parasites* turn up in places that the official culture has ignored, the **White Spots** are engaging with their context. The map already shows 15 spots, the remaining 30 will follow.

References:

e.1. Tobias Rehberger, Offenes Bad und Mobile Bar, Skulptur, Munster, 1997
e.2. Jan van Grunsven, proposal for visual art, Velzerbroek, 1992
e.3. Krijn Giezen, white spot in expansion plan of city polders, Dordrecht, 1983
e.4. Job Koelewijn, mobile cinema, Ooststellingwerf and other locations, 1999
e.5. Herman de Vries, sanctuarium, Skulptur, Munster, 1997
e.6. Gelatin, Weltwunder Expo 2000, Hanover, 2000
e.7. Fischli und Weiss, Garten, Skulptur, Munster, 1997
e.8. Leo Schatzl, Tabuzone, Münzbach,

V FINANCIAL AND INSTITUTIONAL UNDERPINNING PROPOSAL

Organizational Basis: Establishment and Management

The implementation of Beyond requires a compact and decisive organization, with close links to the public authorities. A foundation offers the appropriate legal form for this. Commissioned by Utrecht City Council and other possible financiers, a foundation can be given the responsibility for the development and realization of the scenario and for organizing the related communications. The Beyond foundation can be established for a period of 15 years. The continuing objective: 'The promotion of a locally, nationally, and internationally attractive urban cultural climate in Leidsche Rijn, whereby the attention is particularly focussed on contemporary art projects, which are introduced into the development of spatial planning, and the stimulation of the relevant interaction with residents and interested parties.'

For this the foundation uses the following methods:
– The conducting of research into landscape development, the history of occupation, and the social, ecological and community developments in and around Leidsche Rijn, and the production of a publication on this.
– The formulation of art assignments in Leidsche Rijn, which are in keeping with this scenario.
– The organization of the social debate, and the interaction with the residents involved concerning the art.
– The organization of activities in Leidsche Rijn that promote urban variation, differentiation, cultural development, and the function of urban breeding ground on the outskirts of the city.
– The awarding of art commissions to visual artists and other designers, and the provision of the appropriate guidance for these commissions, in relation to the spatial development and the administration of the (public) space.
– Looking after the communications concerning the development and realization of the scenario for art.

During the realization of its goals and activities the foundation works together with the relevant council departments and the private initiative that presents itself in the sphere of art and culture in Leidsche Rijn, and it goes without saying to establish connections in the field of education, and with the city's existing art institutions. It is, in fact, because of the prominent significance of the communication mechanism that the arts plan is able to evolve into a strategic order during the realization process, to include for

example, significantly more hardy and classical forms of art than anticipated in this scenario. Beyond is deliberately elastic and will, therefore, be completed in the course of time. At a certain point in time a finished picture will emerge, only to be absorbed and reshaped in its turn.

The face of Beyond, to be appointed by the foundation's executive committee, is the artistic director for visual arts in Leidsche Rijn, who will take charge of the further development and realization of the scenario with a great deal of personal commitment and inspiration. Until an artistic director comes forward, the project team, responsible for the content and composition of this scenario, will remain active to allow the smoothest possible transition from plan to practice. After a brief handover period between the team and the artistic director, the former will be clocking off permanently. With the realization of the plan a thorough attempt is made to establish local support, which also means making connections with Utrecht's art circuit. The elastic and transparent definition of form and programme in the new urban field also, however, demands that the application of art has a meta-local perspective, open to the outside world. By organizing open and closed competitions for the development of art concepts, the artistic director can stimulate the artists' engagement with Leidsche Rijn.

Financing

The plan for the exploitation of Beyond spans a period of 15 years and follows the frame of reference that applies to the facilities being installed in Leidsche Rijn, and the general framework for the development of land on site. When the foundation ends its activities, the Utrecht City Council will decide on how to continue exploiting this art project. A number of the initiatives and projects included in this scenario have already been financed for the preliminary phase: this applies particularly to the preparatory motivational essays, and the elements of the previously described 'foundations'. Moreover, not all the categories in the art project require an additional budget: this applies specifically to art in urban design projects. The idea being that the integration of artists into regular civil engineering projects should preferably be financed through regular budgets, such as that for the furnishing of the public spaces.

This leaves enough money for the remaining art projects, for the communication system **Looping**, as well as for the artistic director and the process guidance. The plan for Beyond is a form of cultural property development. The plan generates added value through strategic and dynamic investments, methodically integrated as far as possible into the

regular spatial development. The revenues created by
this added value flow back into the art and culture
of Leidsche Rijn. And so, as they say, you have to
speculate to accumulate: on balance, a larger budget
is available than would have been the case with the
traditional method of awarding commissions.

Bernard Colenbrander,
January 2001

'Beyond – Leidsche Rijn: The *Vinex* Assignment for Art', was written as a result of the activities of the project team Beyond

* The term *Vinex* refers to the large-scale government building policy described in the Fourth Memorandum on Spatial Planning Extra (Vierde Nota Ruimtelijke Ordening Extra)

Project Team Beyond
Peter Kuenzli (chairman)
Jan van Grunsven, artist
Bernard Colenbrander, architectural historian
Mariette Dölle, coordinator art projects dept.
Cultural Affairs Utrecht City Council
Tom van Gestel, project coordinator SKOR
(Foundation for Art and Public Space), Amsterdam
Govert Grosveld, project coordinator SKOR
(Foundation for Art and Public Space), Amsterdam

The scenario 'Beyond – Leidsche Rijn: The *Vinex* Assignment for Art' is an initiative of the department of Cultural Affairs, DMO Municipality of Utrecht, with the participation of:
SKOR (Foundation of Art and Public Space), the Ministry of Housing, Spatial Planning, and the Environment – IPSV Programme, K.F. Hein Foundation, Elise Mathilde Fund, with the cooperation of Property Development Leidsche Rijn.

Municipality of Utrecht
Bureau Beyond
P.O. Box 8613
3503 RP Utrecht
the Netherlands

65

COR WIJN

BATTLING THE UNEASE

REFLECTION ON TEN YEARS BEYOND

Art in the public domain tends to be rather an insiders-only affair, especially at the planning, conceptual stage. This certainly applied to Beyond. Defining this programme of art for Leidsche Rijn, in the late 1990s, took a long time. A project team, appointed by the Visual Arts Advisory Committee for the municipality of Utrecht, designed a scenario, aiming to map out broad outlines rather than to formulate a policy on commissions or write rules in stone. The underlying idea was of art as the driving force behind urban life. This reversed the usual relationship between art and urban planning: instead of art being added afterwards, it would be the first element to take possession of a given space. Scope would be created for other initiatives besides institutional construction projects.

Separate parts of the programme focused on the set objectives: the temporary designation of locations as *parasites* (sites for mobile architecture and experimental forms of light urban development); keeping certain plots of land within the development area free to be used for temporary art projects; encouraging debate on private commissions and the significance of living environments; creating unsettling interventions in everyday life in the Leidsche Rijn area; and communicating about the desired development of this new part of the city with the people of Utrecht as well as with national and international professionals in the field.

Some of those who helped to devise the Beyond scenario were not involved in its implementation. They gradually changed from initiates to outsiders, people observing from a distance. Now that Beyond is winding down, it seems a good time to invite them to comment. What were the original aspirations of Beyond, and to what extent have they been fulfilled? Which elements succeeded and which were woeful failures? And could a Beyond -like programme be repeated elsewhere? Cor Wijn, the programme manager for Beyond from 2003 to 2007, put these questions to Peter Kuenzli, Bernard Colenbrander and Martin Mulder.

In March 2001 a seminar was held in Utrecht about the role of the visual arts in Leidsche Rijn. The Beyond project team presented its

Cor Wijn

F

plan to a select group of architects, artists, public administrators and bodies involved in granting commissions. The most striking contribution came from Chris Dercon, who was then still director of Museum Boijmans Van Beuningen in Rotterdam. Dercon had outspoken views about the relationship between art and society, and he was invited to present his reactions to the Beyond scenario.

Dercon took the opportunity to denounce the Netherlands' consensus society. What had happened in Leidsche Rijn, he said, was that 'art policy' had been superseded by a communication strategy intended to help implement the overall project, the construction of 30,000 new homes in the polder region around Utrecht. Peter Kuenzli and Martin Mulder concede that Beyond was partly instrumental. Kuenzli: 'To some extent Dercon was right. Riek Bakker's original urban development master plan did not contain any cultural elements at all. I was therefore totally in favour of adding culture as a fourth pillar – besides the economic, social and physical planning pillars – to the necessary transformation process. Even so, it would be fair to say that we stayed on the periphery with our plans for Beyond: we did try to be provocative, but we did not always succeed. In fact what we have learned from this whole experience, perhaps, is that a cultural programme cannot penetrate to the heart of that big machine. The cultural components tend to elicit symptoms of rejection. A good analogy, perhaps, would be a small Greenpeace boat: the art programme chains itself to the monster of urban development in the idealistic hope that it can be an agent of change, create something different. That the

Peter Kuenzli was director of Leidsche Rijn Project Office from 1995 to 1999, besides which he chaired the Beyond project team and acted as its driving force. He is the director of Gideon Consult, in which capacity he serves as project director or consultant of numerous complex urban regeneration plans.

Martin Mulder was project manager of housing locations within the Leidsche Rijn project office and a member of the jury in the competition for designs for artists' houses ('House for Sale') that was organized by Beyond. He is currently director of urban development for the municipality of Utrecht.

impetus came from the municipal authority could be construed as a perfect example of Herbert Marcuse's notion of 'repressive tolerance'.

Bernard Colenbrander, who like Kuenzli spent his formative academic years in the 1970s with the ideas of the Frankfurter Schule, agrees. In Marcuse's essay 'Repressive Tolerance' (1965), capitalism and democracy are depicted as totalitarian and repressive systems. Marcuse saw repressive tolerance as a technique in which the establishment tolerates undesirable ideas in the hope of draining them of their effect. In other words, repressive tolerance has little to do with real tolerance; on the contrary, it is a strategy designed to undermine ideas that are *not* tolerated.

Bernard Colenbrander served on the project team as architecture historian. He also compiled and co-authored 'Beyond – Leidsche Rijn: The Vinex Assignment for Art'. He is currently professor of architecture history at the Architectural Design and Engineering unit of Eindhoven University of Technology.

Colenbrander: 'Beyond was unquestionably inspired by ambivalent motives. We think up projects like Beyond because we are dissatisfied about ourselves. We are fully aware that reality is shaped by market forces and try to compensate by inserting scope for recalcitrant ideas. In our everyday lives, we have lost all sense of the sublime. So we yearn for something that transcends the banality of common experience. But the question arises of whether art can act as a countervailing force against the commonplace or if it is just a placebo. Perhaps creating scope for art is only a kind of repressive tolerance: a way of subsuming ideas regarded by the establishment as undesirable into the status quo precisely to neutralize them.'

This suggestion recalls Chris Dercon's observation during the seminar that the real disruptive forces in Leidsche Rijn had already been defused: the proliferation of fences and other partitions erected in the Langerak neighbourhood had been stopped, because they created a messy appearance. Dercon thought that Beyond should have asked Hans Aarsman or Alan Sekula to record these

events in a book of photographs. He spoke of a 'naive and opportunistic faith' in the artist's expertise, while at the same time a large proportion of the construction programme had been surrendered to market forces. Dercon railed against this ambivalent and instrumental attitude, which he saw as characteristic of numerous art programmes.

Quest for Recalcitrant Formulas

Martin Mulder agrees that Beyond was characterized by ambivalence from the outset. He relates this to trends in public administration since 1945: once patrons of the arts, public authorities have instead become regulators, bodies that lay down legal frameworks and rules but leave the building itself to the market. In other words, the government can insure but seldom inspire. Mulder: 'Viewed in that light, given that Beyond was a municipal initiative, some parts of it have been enormously successful. Deviations from the norm, radical concepts, have acquired a place within the development of Leidsche Rijn. But that's actually quite a cynical view to take, and I'm not in favour of taking a purely cynical view of Beyond. It has included some really great projects, which have absolutely been worthwhile.' As examples Mulder cites the project *Roulette* by Manfred Pernice, which he believes helped to get rid of everyone's fixed ideas about roundabout art. The great thing about *Roulette*, in Mulder's view, is that it is not just a marvellous parody, but also a flexible artwork that engages substantively with the relationship between the old and new city.

The paradoxical fact that while Beyond was an initiative launched by the municipal authority it was also intended to agitate the establishment and challenge prevailing views is a common theme in all the reflections about Beyond, from the beginning to its final phase. The programme's contradictory nature is also reflected wonderfully well in its various modes of presentation. Its office was located, for practical reasons, right in the middle of the buildings

occupied by the Leidsche Rijn Project Office (the local authority's planning machine), but it had its own highly idiosyncratic, non-bureaucratic ambience. Mariette Dölle, for years the driving force and source of inspiration behind Beyond, seldom acted like a local official. In the main, she left Beyond free to present itself to the outside world as an autonomous entity, defining her own role – deliberately vaguely – as coordinator, project leader, secretary or programme manager. If Beyond needed extra money from sponsors and cultural funds, for instance, or if government regulations needed to be interpreted creatively, the municipal framework faded into the background and the Beyond Foundation would suddenly emerge in the limelight, a body that possessed legal personality and was competent to conduct legal transactions, but was set up under the auspices of the municipal authority.

Without this ambivalent approach, Beyond could never have carried out the projects that eventually materialized. In Colenbrander's words, 'Beyond set out on a deliberate quest for recalcitrant formulas. It wanted to create space for unorthodox approaches. But its origins within the municipal authority made it seem a bit like a society of free thinkers founded by the government. The fact that some of Beyond's programme lines fell by the wayside may suggest that they somehow exceeded the bounds of repressive tolerance. Somewhere, it seems, the market says: "That's as far as you can go." It would be worthwhile to research the obstacles that Beyond encountered. Where did some things go wrong, and why? Such a study could turn out to be more interesting than the projects that did succeed. I should say that I don't agree with Dercon's view that Beyond adhered to a one-dimensional approach in which artists were committed to the government's tactics in a kind of top-down operational structure. The practice of urban planning is a good deal more complex than that, and in the case of Leidsche Rijn a definite effort was made to devise programme lines that would create real scope, literally make space for bottom-up initiatives, originating with artists themselves, outside the regulatory frameworks. Mind you, I

Cor Wijn

should add that I don't actually see anything wrong with appointing artists to functional positions. Sometimes you need a bit of lateral thinking to invigorate a neighbourhood. Just following market trends won't work.'

The Limits of Repressive Tolerance

In 2003, *Open*, the Dutch journal on art and the public domain, published a special issue on art projects that had fallen by the wayside. The issue generated a lively debate. Art in the public domain has a counterpart, a kind of alternative universe of rejected projects that exist in parallel to those that have been carried out and are perhaps at least as numerous. In relation to Beyond, Bernard Colenbrander would like to see a study of this fascinating subject. It would provide a vista of stranded projects that received artistic approval but were never implemented, from proposals for a car wash business designed by artists to NL Architects' plan to decorate tunnels under railway tracks in Leidsche Rijn and the idea for converting a pylon for residential use.

Peter Kuenzli sees White Spots – on paper in any case ○ as the most interesting programme element of Beyond. He talks enthusiastically about the underlying idea, that Beyond would purchase space in the different sections of the overall Leidsche Rijn plan that had not yet been completely filled in. For the time being, Beyond would not build on these pieces of land, but use them for art projects. After a few years, the plots with the art projects could be re-inserted into the construction programme. That would help to meet the need for additions to the original construction programme that so often arises later on. The art projects would be funded from the anticipated increase in value of the land in this area. At the same time, of course, it was hoped that the art projects would generate something, would lead to a certain development, as a result of which something might be built that would be quite unlike what the urban planners had originally envisaged. Kuenzli: 'As I understand, this programme foundered because in 2001/2002 not one

department within the municipal authority was willing to accept the risk that the land might decline in value, something that was then seen as a serious possibility on account of the economic dip that followed in the wake of the attacks of 11 September 2001. In retrospect, of course, this is a great pity. If you look up the trends in land prices over the past five years, you can see that it would have been possible. In this case, the local authority should have adopted a more unorthodox line of thought. It is a pity especially because these "Blank Spaces" would have added variety and unpredictability to the regular building programme. This example shows that Beyond stayed on the periphery. It tried to engineer intervention and provocation, but it did not touch the heart of the system.'

In Bernard Colenbrander's view, 'Regiekunstenaars', in which artists were attached to design teams, became an underachieving programme line. Admirable efforts were made and exciting projects were set up, but none of it resulted in artists influencing the large-scale plans for Leidsche Rijn. 'Projects like designing car wash businesses (originating from an idea by Hans Eneman and managed by Hans Venhuizen) and the decoration of tunnels under railway tracks (proposed by NL Architects) were really promising. I would like to know why these projects foundered. Were the conditions too complex? Or did Beyond run up against the limits of repressive tolerance here? I have heard that Beyond may become involved in a design for a cemetery. That would be fascinating, and I hope something comes of it.'

A Countervailing Force to Market Power

Fortunately, many art projects were realized. The enthusiasm they generated makes up for the critical reflections. Martin Mulder mentions the exhibition 'Parasite Paradise' (2003) as an example of what you can achieve with a strong artistic concept. 'Many houses had already been built by then, but for the first time Leidsche Rijn was suddenly front-page news in the national press. It showed what a complete village with lots of fantastic *parasites* could achieve in

public opinion. The added value has to do with symbolism. Art is completely different from building houses. An art programme adds a new dimension. For Leidsche Rijn that was very important. Another example was the Dogtroep performance [not a Beyond project, CW]. In 2003 an audience of over 30,000 people came to a sand flat in Leidsche Rijn to see this company's performance. The 'stage' was bounded on one side by a centuries-old farming area and on the other side by the encroaching city, a new estate under construction. At that interface, Dogtroep created a crossroads in time. It was really remarkable. In ways like that, art can help to write the history of a new district. Only unique events and images can achieve that. Perhaps the *Singing Tower* [designed by the artist Bernard Heesen for Vleuterweide culture campus in line with a local ordinance decreeing that 1.5 per cent of the costs of new construction projects must be used for art, CW] will later be defined as that one truly remarkable object that helps to determine how Leidsche Rijn is experienced. Although it was not a Beyond project, the tower was commissioned in a climate that Beyond had created. That climate, that openness to things other than the dictates of the market, is extremely important to the further development of Leidsche Rijn and the city's ambition to make Leidsche Rijn something more than simply a sprawling suburb.'

Peter Kuenzli and Bernard Colenbrander also see Beyond's projects as valuable to the district's urban development. The *parasite* programme is often mentioned in this context. Kuenzli: 'Art usually follows the built environment. Beyond tried to turn that around so that the environment would sometimes follow the art. The exhibition 'Parasite Paradise' and the subsequent creation of a number of *parasites* in the planning area were key here. We were able to link up with a special exhibition in Copenhagen on the concept of *parasites* and an active organization based in the Netherlands with a good international network. Tom van Gestel, who chaired Beyond's artistic team, has achieved wonders as the curator of 'Parasite Paradise'. It was a marvellous show, which led

to other projects such as the school *parasites* (flexible temporary structures) in Hoogvliet, Rotterdam, and recently to a special project in Nantes.'[1]

Pushing Back Frontiers

Kuenzli believes that you should entice people to move beyond their prejudices. 'Parasite Paradise' gave people a reason to come to Leidsche Rijn, in many cases for the first time. That was the idea, adds Kuenzli, pointing out that Beyond got its name from a passage from the book *S,M,X,XL* by Rem Koolhaas that is quoted on the cover of the scenario: 'For each project there is a beyond, a domain where no jury will follow.' In later years, everyone who became acquainted with Beyond attached their own significance to it: 'beyond' the art we know, 'beyond' what is familiar to us in urban development, 'beyond' the frontiers of the commonplace, 'beyond' the existing city, 'beyond' the Amsterdam-Rhine canal, 'beyond' Utrecht, or 'beyond' conformity to market forces and the stereotypes of new housing estates.

Critics in other countries responded enthusiastically to this motto, witness the enormous amount of publicity that Beyond received in the international trade and popular press and the invitations that poured in from all parts of Europe to come and talk about Beyond at conferences and seminars. In fact, the international response was strikingly more enthusiastic than that from within the Netherlands. The main reason for this, perhaps, is that other countries have less experience than the Netherlands with such large projects for the building of entire new districts and that they were therefore fascinated by the ambitions of Beyond and the sheer size of the Leidsche Rijn urban planning project. Kuenzli sees this as an important element. He cites the frequent inflexibility of urban development programmes: the larger they are, the more inflexible they become. There is little room for the unexpected; yet this is an indispensable quality for a truly urban environment. He saw it as the

1 'Loire Estuary 2007-2009-2011' is a project devised by
 Jean Blaise, director of Le Lieu Unique. The project
 includes a series of *parasites* in the Loire delta
 between Nantes and the sea.

Cor Wijn

role of Beyond to provide scope for this, and praises the decision of Beyond's artistic team to use the parasites for a number of cultural centres: a theatre, an exhibition space, an archaeological centre and a temporary cinema. 'Look what's happened with *The Building* that Stanley Brouwn and Bertus Mulder designed. The new city centre has been, as it were, draped around it. The building, which was initially intended to be temporary, has become a permanent fixture. Or take the *Paper Dome*, Shigeru Ban's theatre tent. It has become central to the whole debate about performance venues in Leidsche Rijn. If art can have the effect of making urban development decisions more focused and supplementing them, it has added value.'

Bernard Colenbrander largely agrees with Kuenzli, although he sees it less from the vantage point of urban development and more from the role that artists, architects and craftsmen can play in today's world. 'If you do not take action, an area containing over 30,000 new houses will become a black hole, culturally speaking. You can't solve that by bowing to market forces. In that sense, Beyond was a wholly justified programme. In our society, in which the service economy has become so dominant, we really need actions that can help to shatter the sterility and stir things up a bit. Create opportunities for people to have authentic experiences, ensure that a design process is treated with the care it deserves, preserve – or reinstate – the role of professional craftsmanship in the making of things. That's what I find important. And if Beyond has contributed to that, on however small a scale, it was valuable.'

Responsible Commissions

The completion of Leidsche Rijn certainly does not mean the end of building new neighbourhoods and districts in the Netherlands. There is still a housing shortage, and national government and provincial authorities have agreed on new targets for the number of new houses to be built. Utrecht itself already has new plans for further expansion, this time in a southerly direction in the Rijnenburg polder.

The question is whether a method such as Beyond could be repeated – in Utrecht, in the Netherlands, or elsewhere. Kuenzli: 'To some extent Beyond's role was cosmetic, but it definitely had added value nonetheless. In fact the cultural component should be involved at an even earlier stage of the planning process so that it can make its influence felt. This is what happened with the reconstruction of Roombeek (Enschede);[2] the end result is that the visual art there is perhaps rather less dominant and of less high quality, but numerous cultural centres were created, some in old factories and other existing premises, and others in new buildings. What matters most to me is the creation of facilities like that, which complement the programme dictated by market trends in important ways. This should be part of every process of spatial transformation.'

According to Martin Mulder, what Beyond teaches us is the importance of responsible commissions. In his view, some of Beyond's projects showed that if commissions are defined responsibly, they can add something essential to the choices offered by the market. We managed to ensure that Leidsche Rijn is associated with responsible commissions. Mulder gives a few examples: *The Wall*, the futuristic combination of sound barrier and multifunctional building along the A2 highway, the school Forum 't Zand by VenhoevenCS architects, and the designs for cubic houses in Terwijde, a commission in which the architects' plans were not allowed to exceed a maximum size of 10 x 10 x 10 m.

'There is actually something quite paradoxical about the whole notion of responsible commissions. On the one hand it's about formulating exactly what you want, and on the other hand you have to dare to leave space to accommodate a radically divergent concept. Beyond set an example in that respect. I think that there are lessons to be learned here for Utrecht's future, too. For instance, I have reservations about the plans that have just been

2 Roombeek became known when a firework disaster caused widespread devastation there, with 23 deaths and about 950 people sustaining injuries. Many houses and old factory complexes were destroyed or badly damaged. After the disaster, Enschede city council had the neighbourhood rebuilt along modern lines.

presented for the Rietveld Park. Rietveld doesn't make new things any more. Rietveld's message, the best expression of which, of course, is the Rietveld-Schröder House, is that a well-defined commission is at the heart of every new project. If Utrecht really takes that message on board, the importance would far outweigh the building of a Rietveld Park. Creating a climate in which something new and unique can be produced, that's what really matters.' And Mulder adds, not without irony, that what he liked most about Beyond, perhaps, was that it was so elitist. What he means is that Beyond moved in different spheres of thought and action than those occupied by the average inhabitant of Utrecht. 'Thinking along democratic lines has become the norm in our times and is therefore much easier to do. By adopting a more elitist approach, you can add something different to the market-led creation of houses, neighbourhoods and towns,' he says, in a rather Nietzschean 'untimely meditation'. This brings Mulder back to Chris Dercon's point that art should be at the heart of a new project, not a functional supplement.

111

UP AND RUNNING! BEYOND FROM WITHIN

MARIETTE DÖLLE

Mariette Dölle coordinated the implementation of Beyond between 2000 and 2006 from the Cultural Affairs department of Utrecht municipal council. Henriëtte Heezen asked her to look back on those days of commissioning art projects for Beyond.

Beyond took years to germinate. As far back as 1996, Mariette Dölle was involved in talks between the then head of Cultural Affairs for the municipality of Utrecht, Hennie van Tilburg, and the then director of Leidsche Rijn, Peter Kuenzli, about the scope for expanding the policy on art commissions to include this new residential district. The answer was always the same: 'No money without a plan.' A series of meetings with experts from the art world culminated in the advisory report *Kunst voor Leidsche Rijn. Een sneeuwbal van 10 miljoen* (Art for Leidsche Rijn: A Snowball Worth 10 Million) by the external author Hans den Hartog Jager. Mariette Dölle recalls: 'Hans thought it appropriate to take a title with a subtle allusion to David Hammons's performance *Blizzard Ball Sale*. Hammons stood in the streets of New York one winter's day selling perfectly spherical snowballs. Selling snow was an oblique reference to a slang name for cocaine, but at the same time it was a tribute to the power of imagination in art.'

Those were the golden 1990s, and the city council responded to the advisory report by allocating a budget of €7 million to the new art project for Leidsche Rijn. Since most of this money had to come from land development within Leidsche Rijn, it seemed only logical, from the perspective of Leidsche Rijn, that the project office should decide about the art there. But the Cultural Affairs department, which was responsible for the overall quality of the municipal art policy, took a different view. As Dölle explains: 'In the end, the new head of Cultural Affairs, Nico Jansen, managed to ward off an impasse. Two members of the municipal executive, one with responsibility for Leidsche Rijn and the other in charge of the culture portfolio, bore joint responsibility for this ambitious project. So he simply proposed getting more parties involved in the decision making. One was SKOR (the Foundation for Art and Public Space),

which was asked to participate financially and in terms of content. Jansen also proposed putting the former director of the project office, Peter Kuenzli, in charge of a new project group that would draw up a plan. And that's the formula that was adopted.'

Wasn't Beyond's success mostly due to well-judged programming?

'Some people might say that good art is the result of good curators and efforts to find great artists. I don't see it that way. There's nothing difficult about thinking up an art commission, the hard part is actually putting it into practice. In the hectic arena of the public space, views about artistic quality are scarcely heard. To achieve high quality in art commissions, it is far more important, in my view, to set up a body with real expertise, a body with a strategic vision of the parties representing their interests in the public space. Beyond turned out to be one of the most successful large-scale art projects in the public space, because a group of public servants thought long and hard about how to create a context in which art can do what it is meant to do, without being used as a means to an end. Once the plan for Beyond had been approved, it was no longer necessary for each individual commission to go through long consultation procedures, since they all belonged to the plan that had been approved. None of them had to be individually assessed by the municipal council or its committees, since they were seen as temporary. At Beyond's office, the Cultural Affairs department and the Leidsche Rijn project office worked together, and communication lines were short. While an artist may be an isolated individual with his or her personal vision, the organization was always careful to involve several parties. After all, only part of Beyond's budget came from the municipality. The Ministry of Culture and Science was involved, through SKOR, the Ministry of Housing, Spatial Planning and the Environment contributed a large sum of money, the provincial authority supported projects like the *Paper Dome* and The Building, and a number of funds also contributed. Of course, Beyond

was often discussed at meetings of the city council, certainly whenever some financial emergency arose. At one point in 2005, its survival was even put to the vote. Beyond only just survived that vote, and the involvement of several other players besides the municipality was a key argument in its favour. It is precisely the intelligent organizational construction around the content that helped make Beyond a success, in my view.'

And the artists? Surely, they had to work in accordance with a specific programme?

'Most of the artists were surprised at the freedom they were given to submit their own proposals. Every artist knows that the public space is a difficult area in which to produce your work, to be seen and to make an interesting contribution to the civic environment. Many of the artists who took part in Beyond's programme are well-known in international art circles, and precisely for that reason they seldom respond to external commissions. Since Beyond focused on the wider theme of the urban environment rather than on a specific location, renowned artists were willing to accept the invitation. Monica Bonvicini spent a day driving around this brand-new estate in my old Volkswagen, and became so enthusiastic that she produced a wonderful piece – I still feel sad that that we couldn't keep it: battered old lampposts with huge construction lamps hanging from them that looked like jewels. It was a humorous comment on the over-immaculate outdoor space in Leidsche Rijn, with the lamppost doing its best to look smart. Dennis Adams cycled (or perhaps I should say, "had a cycling lesson") around Leidsche Rijn with me and scattered his bright orange bucket seats (like those at a football stadium) all around the neighbourhood as images linking the new estate with the old city. That work, the first one that appeared in Leidsche Rijn, caused quite a stir: one woman turned up at a neighbourhood meeting and said that when she opened her curtains in the morning and saw one of those little seats, it ruined her day. In the summer of 2003, N55 chose a plot of undeveloped land and

called it their work of art; no one was allowed to touch it. A local policeman phoned me in the autumn to say, "There are some sheep grazing on your artwork, is that allowed?" Leaving aside the fact that it was an illegal flock of sheep, there was something rather glorious about the fact that even the police recognized that plot of land as art of some kind.'

Which artworks made the biggest impression on you?

'I remember when Stanley Brouwn arrived and produced two white wooden sticks, placed them one on top of the other at right angles on a square of artificial turf and said: "There you are, that's the design." Those two little sticks eventually led to the birth of an amazing building. In August 2005 *The Building* was finished, an exhibition pavilion based on his design. For decades, Brouwn's great precision and consistency in his conceptual work have made him one of the leading Dutch artists. Under the leadership of architect Bertus Mulder, known for his restoration of the Rietveld-Schröder House, the building was executed to the last detail in accordance with Brouwn's ideas – including its designated purpose. Brouwn wanted an exhibition pavilion: an artwork that would in turn generate more art, and that would – for this new district – challenge the notion of centre versus periphery. Brouwn did not attend the official opening – he dislikes appearing in public – but slipped into the building incognito now and then. And once he called to ask if he could walk around the interior at night.

'The craziest project I ever supervised was the one by the Turkish artist Esra Ersen for the exhibition 'Pursuit of Happiness'. Esra lived at *Nomads in Residence* for weeks. In that time she sought out boys with a Turkish or Moroccan background who lived in the Korianderstraat neighbourhood. The district was still being developed, and people tended to zoom in on everything the young people did. The local youth work organization created a meeting place and recreation centre for them. Esra was curious to know how they related to the wider community. For many residents,

Leidsche Rijn meant a bigger, better house, a bright future. Did the boys feel that this view of the future included them? Did they belong? Esra suggested having a series of jackets printed with phrases about their lives and situation. Each boy would be given a jacket as a present, and we would hang a second series of the jackets in the exhibition. Unfortunately, however, we failed to predict a clash of preferences in fashion styles. While Esra had been thinking in terms of classic motorcycle jackets, the boys all wanted jackets with fur-trimmed hoods. And while Esra wanted to hang up ten identical jackets, the boys wanted each one to be different, reflecting individual tastes. Esra, the boys, the youth worker and I all spent days searching for the right jackets and negotiating about them. Together with the group, we went to Beverwijk Bazaar and umpteen fashion stores in Utrecht; by the end of it we felt we knew every kind of jacket and hood in stock throughout the country. We discussed buttons and zippers, textures, degrees of blackness, stitching, we debated whether hoods had to be detachable. Every jacket was just not quite right. The situation got so bad that at one point the boys nearly backed out. Anyway, we finally solved it just before the opening, and jackets were hung up in the exhibition with the boys' own phrases printed on the back. Next morning I got a phone call, from the attendant: the jackets had vanished, apparently stolen overnight. They were never recovered. The boys did get their own jackets, complete with printed phrases. Whether they ever wore them I don't know.

'Esra Ersen has since included this project several times, or its documentation at any rate, in presentations of her work at the biennales of São Paulo and Liverpool, in Kunstverein Frankfurt and Kunsthalle Winterthur. Because however exhausting it may have been, for her too, she sees this project as making its own comment about the complexity of a new society, one in which groups feel ignored or misunderstood, and in which artists too sometimes find themselves cast in roles they had not foreseen. For me, the project highlighted a topic that had largely escaped our notice up to that

point in our policy on art commissions, and which is now gaining ground in the Dutch art world: more attention for cultural diversity and new sections of the population.'

Have you come to view Beyond differently since 2006, now that you are artistic director of the exhibition space TENT in Rotterdam?

'Now that I'm working in Rotterdam and can look back with more distance, I see that Beyond has a relatively low profile in the Dutch art world. Of course, in its first few years, Beyond was such a surprise that the project's very existence caused quite a stir. Local newspapers gave it plenty of coverage and followed the projects, "Parasite Paradise" made it onto the national news and Stanley Brouwn's work *The Building* was featured on the front page of the national newspaper *NRC Handelsblad*. Representatives of Beyond were invited to speak at symposiums in Cologne, Basel, Rennes, Gdansk, Venice and Milan. The writer of our monthly website cartoon Vicky Vinex turned it into a hilarious show, a monologue about life on new housing estates, which toured theatres all over the country. The enthusiasm seems to have died down a bit now. In part that may reflect current trends in art in the public space. Right now you see interest reviving – among artists as well as clients – in sculpture and other more conventional forms of artistic expression. Beyond's initiative to create a modern sculpture park is part of that. It seems that art in Leidsche Rijn's public space is not so special any more, it's taken for granted, and maybe that's all to the good. Meanwhile, policy on art commissions now focuses on the right things: on high quality and on work that is rooted in society.'

Mariette Dölle

A HUNDRED SEPARATE VIEWS

BIK VAN DER POL

The seventeenth-century sculptor and architect Bernini introduced a new sculptural aesthetic when he captured 'transformation' with a maximum of drama and dynamic. His intention was to create sculpture that could be fully grasped only by circling around it. No longer should there be just one unique and optimal viewpoint. Indeed, the viewer – according to Bernini – had to approach his sculpture like a prey, and would be rewarded by an experience that becomes more and more engaging with the passing of time. His sculpture Apollo and Daphne is based on the story in Ovid's Metamorphoses. Apollo's desire for the nymph Daphne was caused by a golden arrow shot at his heart by Eros who wanted to demonstrate the power of love's arrow. However, Apollo's desire was not mutual, since Eros had shot a second arrow tipped in lead at Daphne's heart, giving her absolute disgust for all things romantic and passionate. Pursued by Apollo, Daphne desperately prays for help and is transformed into a laurel tree.

When approaching the sculpture Apollo and Daphne, which represents the moment of transformation, Daphne is – looking from behind – obscured by the trunks and branches of the laurel tree. Only by walking around the sculpture can one catch glimpses of the full impact of the metamorphosis that is taking place.

Bernini broke the sculpture into a hundred separate views, and the viewer visually and actively has to put the pieces together by moving in space and time.

Creating a fusion between architecture, sculpture and performative action by walking is a landmark in time. Suddenly the coexistence of the viewer's space, the multiple views, the use of distance and close-up, the explorations in new relations to surrounding elements, the importance of time, and the assumption of subjectivism in perception come together and are all set in motion to allow the sculpture to come into existence.

Dismissed is the one-dimensional point of view that sculptures up until that point assumed. Introducing time and space and consequently history and future in one single object, movement has

been brought into the arena. Relations opposed to static and fixed. The viewer has become part of a spectacle, set in motion by the act of walking.

According to Franceso Careri and Gustavo Gili in Walkscapes. Walking as an Aesthetic Practice, (Barcelona, 2002) the history of man is the history of walking. Through walking, areas are explored, mapped, expanded and appropriated. Walking is not just the physical construction of space, but it generates the transformation of a place, of a territory and its meanings, eventually culminating in creating the first manmade vertical line through the erection of the stone – the menhir. The appearance of the vertical line in the landscape – an architectural gesture – marks the three points in space as the basic principles of building: length, width and height. The path, which is the line of walking, creates history and a sense of place. Now one can wander around and connect to different places.

With the arrival of transport, the global landscape drastically changed. Walking accelerated. Infrastructural projects such as the highway radically change and define the architecture of our environment, and continue to do so. The site of experience becomes enlarged, and the road movie is perhaps one of the most particular examples of rambling, from here to nowhere.

Artist Robert Smithson intensively explored the nowhere. He developed the concept of Site and Non-site, in which the gallery was the place where he showed documentation of the actual sites, far away in a remote landscape only reachable by car. Going there one has to move further and further away into the world marked by maps, points and crossroads. One has to embark on a journey, a trip, a grand tour. And even when one arrives at the site, it is impossible to see the whole work. One can travel to Spiral Jetty but arriving there, other aspects of the work such as the film and the maps are out of sight. It is somewhere in the experience of walking along the concentric lines of the Spiral Jetty that a story starts.

Other than with Bernini's Apollo and Daphne, simply circling

around cannot put the hundred separate views together. The viewer visually has to get the pieces together by moving further and further away. The actual travel involves mind-travel. By jumping in a car, following the highway, moving away from the gallery, out of sight, and back again. The sculptural space is enlarged and travelling from and to and the documentation have become part of it. Staging the physical work to become film, the camera becomes the viewer, moving, walking and circling around. The eye of the camera tells you what it feels like to be there, what the temperature is, how empty it is, how unbearable the sun is, and how thirsty one gets. Circling the surface of the earth, and due to the inaccessibility of the site circling takes the shape of desire. In the desire to get there, to embark on the travel, a narrative is being shaped. And if those who may have been there – the community of the inaugurated – tell the narrative, over and over again, myth starts to come into existence.

A highway, urban developments, some landscape in between. We know it. This is the scene so familiar to us today. It consists of infrastructure, cities and suburbs, and includes the conflict zones of human desires and contradictions of the public realm. During the past century landscapes, initially agrarian, have been increasingly, and at a fast tempo, transformed into large urban areas.

Leidsche Rijn is not an exception. Former farming land is rapidly being erased, and on this tabula rasa large-scale pre-planned housing projects do take shape, but the family dream of a house with a garden for everyone has lead to the transformation of a new urban space with concrete contradictions. Ironically, the democratic achievements manifested in the right to the site also create the non-site. Serving everyone creates a loss of meaning. The total erasure of the past as it has been inscribed in the landscape leads to the creation of a 'nowhere', to an urban area that has deliberately distanced itself from history, myths and shared intentions. It has become the single thing, paradoxically creating the urgency and desire to reinvent the diversity of multiple histories,

resulting in the attempt to resuscitate what has been lost.

This desire often leads to organized nostalgia: activities, as for example the selling of farmers' produce along the roadside, the celebration of the ecological and the pure, the spectacularization of an archaeological era, and the replanting of a new orchards in order to retrieve and establish a landmark. Perhaps instigated by a weariness of what the consequence of a 'nowhere' might be, politicians, guided by a continuous fear of loosing votes in the democratic dynamics, search for instruments able to resist singularity. However, mimicking what has been probably does not suffice to make up for the loss. The nowhere has to be tackled, confronted and explored. Narratives have to originate from the new situation, from the now. And these narratives have to create relations that did not exist before, in order to spark off a variety of belonging to the coexistence multiple views.

Artist Vito Acconci once stated that art creates 'a community meeting-place, a place where a community could be formed, where a community could be called to order, called to a particular purpose'. The coming into existence of a community is building upon physical assembly, shared experience, to discourse and to the individual. What art can generate in areas such as Leidsche Rijn is that it can function as a reason to inaugurate and call upon spectators and participants to generate a community – or communities – that comes together to share the stories told, that has the potential to function as a resistance against an (obvious or disguised) power, as a productive tool against the loss caused by, for instance, a singular point of view. Not by creating artificial landmarks in the urban tissue, but by the actual understanding of the whole area as an enlargement of the sculptural space, as something that stretches itself fully into the urban areas and beyond.

With projects such as Manfred Pernice's Roulette, a selection of public sculptures from the City of Utrecht temporarily removed from their locations to a roundabout in Leidsche Rijn, new

histories are actively inscribed in the landscape. Pernice has designed a form of 'sculptural choreography' which makes it possible to display several works on the roundabout simultaneously and in a variety of constellations. Dominique Gonzalez Foerster's Sainte Bazeille is a twin parasite located on top of the remains of a Roman public bath. Nowhere else in Leidsche Rijn is the Roman history so close to the surface. Sophie Hope's Reservaat, Back To The Present, allows a glimpse from the future back to 2007, into the experiment of Leidsche Rijn to create living at a time of great expectations and new beginnings. And our Nomads in Residence/ No. 19, a mobile studio for artists, writers and other observers functions as a test ground, formalizing a certain way of communication and exchange, that otherwise might not happen. These projects are time-based, wandering, and they all provide tools to approach and actively take on the situation through imagination, exploration and speculation.

They are provisional propositions that spark different narratives, narratives that will eventually settle themselves as new myths, typically and specifically from and belonging to this land. Following their footsteps, embarking on an adventure of walking, wandering and moving around with them might fulfil the desire for temporary alliances that could develop into 'love for life', shaping narratives that are flexible, uncontrollable, unfixed and yet undefined. Narratives occurring in such a wandering way create a hundred separate views to which the wanderers will really claim ownership, because it is they who gather to put the scattered pieces together.

Bik Van der Pol

BEYOND – A DURATIONAL NOVEL WAITING TO UNFOLD

PAUL O'NEILL

Dominique Gonzalez-Foerster, Roman de Münster, Skulptur Projekte Münster 2007, photograph Roman Mensing

'Beyond is, in the first instance, an arts project. It's about creating scenarios for adding art as an extra layer, over a longer period of time, to the design of Leidsche Rijn'.[1]

The past 20 years in Europe have seen a surge in public art commissioning as part of urban regeneration, city branding and renewal programmes. In parallel to this, there has been a proliferation of location-responsive artworks being realized in the context of international biennials. While recent years have witnessed a growing understanding of the complexities of art responding to a specific place, a form of cultural nomadism established itself in the 1990s aligned to an increasingly dense international exhibitions market. As curators and artists parachuted in to respond to 'one place after another' as part of a worldwide art trail, far too many took a short-term approach to how art engages with its location and its audiences.[2] Perhaps as a corrective to this peripatetic behaviour, longer-term and durational approaches to public art commissioning have begun to emerge more recently.[3]

Since 2001, the cumulative six-stranded programme of Beyond has developed in parallel with a city extension of Utrecht, as its fledgling communities started to arrive.[4] As a series of commissions in Leidsche Rijn, due for completion in September 2009, Beyond

Paul O'Neill

1 Peter Kuenzli cited in: O. Koekebakker, 'An interview with Peter Kuenzli', in: C. van den Broek (ed.), *Parasite Paradise* (Amsterdam/Rotterdam: SKOR/Nai-Publishers, 2003), 33-34. Kuenzli was the chairman of the project team that framed Beyond, the strategic arts plan for Leidsche Rijn housing development in Utrecht.
2 See Miwon Kwon, *One Place After Another. Site-Specific Art and Location Identity* (Cambridge, MA: MIT Press, 2002), 52. See also C. Doherty, *From Studio to Situation* (London: Black Dog Publishers, 2004).
3 'Locating the Producers' is the title of a three-year international research project looking at this durational turn in commissioning — a collaboration between Situations, University of the West of England, Projectbase and Dartington College of Arts/University College Falmouth. See www.situations.orguk/research_ltp.html.
4 The six categories of the programme are: Looping, Parasites, Artists Houses, White Spots, Action Research and Directing Artists. See for detailed information: 'Beyond — Leidsche Rijn: The Vinex-Programme for Art', Utrecht 2001 (published in this book). The current Artistic Team of Bureau Beyond is comprised of curators Tom van Gestel (Chairman), ▸

aspires to create interventions into a cultural landscape in which the unexpected acts as a catalyst for how local inhabitants think about acting upon their environment.[5] Beyond is exemplary of longer-term public art commissioning projects to have emerged in recent years. Together, these projects form part of a generalized shift towards more durational and sustainable approaches to how art engages with its specific location, urban planning and its public.

This text will consider how Beyond is part of a broader turn in public art commissioning, how it evolves out of a wider reflection on a recent history of public art and how it portrays time and public space as an unfolding novel that reflects on the place of art, its temporality and duration.[6]

Public Space as a Novel Full of Things

When 'Skulptur Projekte Münster' celebrated its 30-year history in 2007, one of the most notable reflections on its past was the work of the French artist Dominique Gonzalez-Foerster: *Roman de Münster (A Münster Novel)*. On a green promenade, the artist's miniature recreations of works by various artists from the preceding 'episodes' of Skulptur Projekte formed a mausoleum to a history of public art realized in one city since 1977. At once

> Nathalie Zonnenberg and Theo Tegelaers. Previous artistic advisors have included artist Liesbeth Bik and curator Govert Grosfeld.

5 For example N55's *LAND*, (since 2003) began when they laid claim to a 300-m☐ plot of land in Leidsche Rijn consisting of a small pasture enclosed by a moat with its own bridge. Marked by a concrete sign with the word LAND, it is a freely-accessible public space that will remain undeveloped — a piece of fertile land available for common use.

6 For Henri Bergson 'duration' is not only a psychological experience — a transitory state of *becoming* — it is also the concrete evolution of creativity, as a state of being within time that succeeds itself in a manner which makes duration the very material of individual creative action. For Bergson duration is always evolving through our actions 'in time', allowing for the unknown to be brought to the fore *in a manner that does not foresee its own formation* during or within the course of action. For Bergson, duration is something that ▸

nostalgic, celebratory and fun, *A Münster Novel* provided a version of an evolutionary history in short-hand, with all its complexities, temporalities and site-specificities reduced to a collection of small, heterogeneous objects, laid out together. This pared-down storytelling reminds us that a narrative filled with objects is not a novel at all; without characters, places, conversations, descriptions or storylines to compel us, we are left with a populated field of detached things. As a comment on recent history, Gonzalez-Foerster shows how art has played a supporting role in transforming public space from a complex, fragmented set of social, political and economic relations into a marketable identity. One of the key questions when commissioning today is: how can art in public space emancipate itself from the expectations of architects, developers and town planners who frequently regard it only as a means of prettifying their designs?[7] *A Münster Novel* demonstrates this dilemma, by effectively reversing notions of the 'temporary' and the 'permanent' of public art in place.

Similarly, this reversal is also perfectly exposed in Manfred Pernice's work for Beyond's 'Sculpture Project Roulette'. On a temporary roundabout at the motorway entrance to Leidsche Rijn, the artist curates alternating constellations of existing permanent public art works from the old city of Utrecht by selecting, categorizing and placing them together. Situated on the border between the old and new Utrecht, Pernice's arrangements of 'families' or 'types' of monumental public sculptures are removed from their more permanent sited locations in the city of Utrecht and temporarily displaced to the roundabout. The work is a simple but effective spatiotemporal gesture, undermining the absurd and often

> endures because change is the substance of duration, materialized through a transitional process that is taking place in time through a capacity to move from one state to another. See: Suzanne Guerlac, *Thinking in Time. An Introduction to Henri Bergson* (New York: Cornell University Press, 2006), 1–13.

7 L.A. Hartl, 'How Much Art Can Public Space Tolerate?', in: C. Büttner et al. (eds.), *Kunstprojekte_Riem. Public Art for a Munich District* (Vienna/New York: Springer-Verlag, 2004), 26–27.

random nature of public art and its commissioning history.

In an earlier contrasting work by Gonzalez-Foerster, also commissioned as part of Beyond, the artist illustrates how the art object can behave very differently when its primary audience is not that of a mobile art world. Formed of two buildings, sited in open fields within residential locations, *Sainte Bazeille* (since 2006) takes a very different approach to storytelling than that found in *A Münster Novel*.[8] Each building is made up of two intersecting architectural forms: a horizontal silo and a shipping container. As a dual symbol of labour past and present, of farming and industry, these structures connote the disappearance of the countryside to make way for housing and business. Both buildings are employed for local research and pedagogical activity – one as a presentation space for natural and environmental education; the other to display Leidsche Rijn's rich archaeology. *Sainte Bazeille* acknowledges the significance of history, from the perspective of the future inhabitants of the area, by acting as a reminder of the ways in which art can function as a tool for reflecting upon the past, and as a potential repository of knowledge. In contrast to the Münster work, *Sainte Bazeille* reveals how the autonomy of the artist and the artwork have radically shifted away from sculpture that is integrated, but formally detached from its surroundings to become an art that engages directly with its immediate environment without falling foul of monumentality, decoration or short-term social effect.

Beyond as a Novel in Search of Its Own Identity

Beyond owes much to the legacy of environmental art in the Netherlands, as encouraged by the 'Arnhem School' (Arnhem School is an epithet of the Monumental Arts Department of the Academy in Arnhem, under direction of Berend Hendriks and Peter Struycken) in the 1970s, and to the idea that architects, environmental designers and artists could work together in an interdisciplinary way to provide public spaces with more complexity, variation and sociable orientation as part of an overall planning process.

8 The building was designed by the artist in
 co-operation with architect Martial Galfione.

In the late 1970s, not far from Leidsche Rijn, 'Lunetten' represents one project influenced by this approach to environmental art. Here, Wim Korvinus and Marcel van Vuuren coordinated artistic commissions for a brand new suburb on the outskirts of Utrecht called Lunetten. The main objective was to facilitate more variable urban design so that socialized public spaces could be created by art's design role in the formation of more 'authentic places'.[9] The project's problems were manifold, with the six commissions being dispersed over several years with little relationship to each another and the staggered realization requiring too much of an improvisatory approach from those involved, leading to a mishmash of projects. But the most evident failure was the impossibility of 'authenticity' being enforced artificially, through urban planning and permanent interventions over a short timeframe.[10]

Through diverse modes of engagement and as a means of promoting urban life rather than realizing it, Beyond has attempted to re-write these failures, and to show how art can be part of the genesis of a place without being confined to the forming of its authentic identity. Beyond has consistently promoted social and spatial practice via temporary art interventions, events and social sculptures, commissioned with the intention of enabling civic interactions, social gatherings and discussions. Mobile architecture and temporary built environments have been central to these experiences, and the overall programme has been orchestrated for a diverse public and permeated with a kind of festival spirit. As such, it may be considered as a series of short-term interactions within a longer-term project, with the overall timeframe being long enough to allow real experimentation to occur and for a situationally informed practice to emerge within Leidsche Rijn. It has facilitated multiple encounters between art, people and places by inducing and stimulating memories, debates and experiences. In doing so, Beyond

9 See C. Van Winkel, 'Authentic Places. Lunetten and
 the Demise of Environmental Art', *Archis* 8 (1999).
10 Realized between 1974 and 1984, the artists as
 designers were Cornelius Rogge, Kees Wevers, Marian
 Van Lookeren-Campagne and Henk Lampe, Bas Maters,
 Koos Flinterman and Jan van Wijk.

has also consistently challenged what is defined as the permanence of public art.

The durational rationale for Beyond is three-fold. Firstly, it was developed in tandem with the urbanization process. Secondly, when Beyond began, Leidsche Rijn was under construction and lacked basic facilities for its first residents – there were too few people living there to justify amenities such as shops and social and cultural spaces. So, for example, Shigeru Ban's Paper Dome (2003) embodies mobile architecture for cultural activities, performances and events programmed by local agencies, Stanley Brouwn's *Het Gebouw* (since 2005) acts as a local arts centre and exhibition space, and *Nomads in Residence/No.19* (2003, designed by Bik Van der Pol in co-operation with Korteknie/Stuhlmacher Architecten) serves as a mobile research-based artist-in-residence workspace. The third durational aspect of Beyond lies in the reflexive study of art in the public sphere which asks how this model for commissioning public art contributes to thinking about how curators, commissioners and artists relate to the particularities of the area or react upon the specific situation.

While dealing with the dilemmas concerning the architectural and spatial programming of new urban environments, Beyond has retained a semi-autonomous position within the overall planning and municipal process, being both within and outside the city's central administrative structure. It has resisted reducing the prevailing tendency, arising from commissioning in urban renewal contexts, to restrict art either to short-term social impact or to problem-solving.

The Durational Turn in Public Art

Commissioning for the long-term is not only a question of time, but it represents a commitment to engaging art in, and for, a single place with its most immediate audiences. As a co-operative procedure linking many actors and agencies, it involves the coming together of a range of individuals with various objectives in common for an extended period of time. In this way, durational praxis can make

possible a mode of co-production for all those who take part in a slowly unravelling narrative that considers the involvement of residents in the process. When artists, curators and commissioners contribute to sustaining a practice-in-place for a period of static, immobile time, with a view to leaving something behind that could not have been anticipated, there is a prevailing belief that the duration of a commissioning process matters.

Beyond is exemplary of a more general durational turn in public art commissioning.[11] 'Nouveaux Commanditaires' in Bourgogne (since 1997) began as an innovative patronage model conceived by François Hers to support the production of utilitarian public art primarily for rural contexts, realized through a collaborative process and commissioned by the citizens or associations directly involved in the conception, production and ownership of the artwork.[12] 'Breaking Ground' (since 2002) started as a programme of contemporary art commissions in line with a Dublin suburb undergoing major regeneration as part of a partnership with the developers, Ballymun Regeneration Committee and in constant dialogue with the established local communities there.[13]

11 Foremost projects by artists also include *Park Fiction* Hamburg (since 1995), Rirkrit Tiravanija's *The Land* in Chiang Mai (since 1998) and Jeanne van Heeswijk's *Het Blauwe Huis* (since 2004). *Park Fiction* halted plans for construction on the last remaining open space in St Pauli and initiated a collectively-designed park through the organization of a local network that sustained a parallel planning process, creating platforms for exchange among people from many different cultural fields. *The Land* is a community in which artists conduct projects among the rice paddies, vegetable fields and water buffalo, the value of which is counted primarily in terms of utility and sustainability. *Het Blauwe Huis*, due for completion at the end of 2009, was initiated by artist-commissioner Jeanne van Heeswijk in 2004 when she arranged for a large villa in IJburg to be taken off the private housing market and employed for a four-year period as a residential space for artists and interested practitioners, with a view to enabling participatory research and place-responsive cultural production to take place within IJburg and to respond to conditions of a new urban development.

12 See www.nouveauxcommanditaires.com.

13 See www.breakingground.ie.

And 'Grizedale Arts' (since 1999) is a research and development agency for artists, which has led to an ongoing programme of events, projects and outdoor exhibitions. Grizedale Arts takes a residential approach where artists are invited to spend time in Cumbria and reflect upon the immediate social, cultural and economic environment of the English Lake District.[14]

Most similar to the commissioning context of Beyond are two art projects in Germany and Denmark realized in dialogue with new residential areas undergoing construction: 'kunstprojekte_riem' (2000-2004), and, more modest in scale, 'Kunstplan Trekroner' (ongoing since 2002). Curator Claudia Büttner's 'kunstprojekte_ riem' was undertaken by the City of Munich with a view to making art for Messestadt Riem, a new suburb containing the city's trade fair centre and intended to accommodate 3000 new residents over four years. Over four years, a range of art forms from objects, to installations, actions, public discussion forums and participation projects focused on how art could shape the future of a residential space through 'art in the public interest'.[15] Four different thematics provided focal points for artists, beginning with 'city markers' in 2000 which dealt with the topography of the site as it was being built. Subsequently, 'residential worlds' engaged art directly with new citizens moving into the area, then 'social spaces' focused on art intervening in public spaces as they were built, and 'periphery and centre' explored how connections could be drawn between Messestadt Riem and the city centre of Munich in 2004. Each emphasized the necessity for on-site research and illustrated how an arts project could adapt to the changing situation of an area under construction while regarding new residents as the main client.[16]

14 An example of this approach is 'Creative Egremont', 2004-2008, when Grizedale Arts was invited by Egremont and Area Regeneration Partnership to rethink how the arts could improve life in Egremont and its surrounding area. For documentation of past projects, see www.grizedale.org.
15 C. Büttner, 'kunstprojekte_riem. Ideas and Progression', in: Büttner et al., Kunstprojekte_Riem, op. cit. (note 7), 33.
16 Ibid., 33-34.

'Kunstplan Trekroner' (since 2002), led by artist-curator Kerstin Bergendal, is an on-going programme of semi-permanent works, temporary commissions and exhibitions documenting a residential area undergoing construction. It aims to integrate art commissions into a new urban development born out of a master plan in Roskilde. Bergendal established an open brief, which was accepted by the municipality, where artists would be invited to work within a highly predetermined planning process in Trekroner, and contribute at an equal level to that of the planners, architects and landscape designers. Some of the realized works are physical interventions into the architectural landscape of Trekroner, offering a counter-image to that of the original master plan and intended for future sociocultural activation.[17] But the long-term objective for Bergendal is to give inhabitants the opportunity to contribute to their own built surroundings. Through workshops initiated by Bergendal in partnership with urban planners and landscape designers the inhabitants' desires are fed back through drawings and prototypes to the city planners with a view to being implemented in the future by artists and architects.[18]

While diverse in their outputs and objectives, all of these durational projects have presented a longer-term view of how

17 For example, Nils Norman's *Bridge* (2004) forms a meeting point for residents in the area. As a link across the artificial lake between the new town and the university centre, it is also a place of rest, contemplation and playfulness. Elsewhere, Jakob Jakobsen's *Parking Lots* (2003-04) provides leaf-shaped car parks that differ from the more linear, standardized design of the other lots in the area, which are intended to bridge social divisions between different users of the space in support of counteractive structures and encourage alternative types of social usage, such as a site for an open market place during the summer or a skating rink during the winter months.

18 In 2008 Bergendal hosted a three-part workshop — in collaboration with Jørgen Carlo Larsen, Marianne Levinsen, and Åse Eg — which asked the local owners' association how they might visualize and organize future public spaces in the area. From this process, a proposal was put forward to the municipality which has now been approved in principle and parts of which is expected to be implemented by summer 2009.

A Flatpack 001, Mark Titchner, iDeath and the
Battle of the Bands Competition, commission as part
of 'Roadshow', Grizedale Forest, Cumbria, 2003.
B Jeremy Deller and Alan Kane, Greasy Pole, 2008,
commission of Grizedale Arts, as part of 'Creative
Egremont: A Public Art Strategy for Egremont',
photograph Trevor Kirkwood.

C

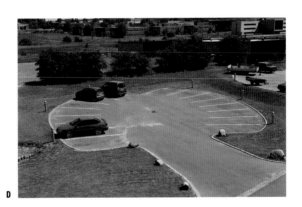

D

C Nils Norman, Bridge, 2005–2006, Trekroner, Roskilde
(DK), has been realized with landscape architect Ib Asger
Olsen, as part of Kunstplan Trekroner, under direction of
artist Kerstin Bergendal.
D Jakob Jakobsen, Car Park, 2003–2004, Trekroner,
Roskilde (DK), has been realized with architects Mangor
& Nagel as part of Kunstplan Trekroner, under direction
of artist Kerstin Bergendal.

commissioners can respond to a specific situation by considering how art can be a co-operative process of production that is neither autonomous nor overregulated. As such, these multifaceted programmes also acknowledge that multiple agents and partnerships are always at work within the commissioning process – from curators to artists to audience, to planners, city administrators, developers and all those responsible for the framing of art's context or situation and its social and spatial reception. The durational projects mentioned here are representative of what Clare Cumberlidge and Lucy Musgrave from General Public Agency have discerned as 'a shifting field' for artistic practice operating inside urban planning processes: 'The belief in the effectiveness of the small action; the use of local distinctiveness and values as starting points within visions for the future; and an emergence of integrated programmes of identity within planning and implementation.'[19]

As 'duration-specific' projects of diverse modes of artistic interventions, longer-term and accumulative programmes propose a sustainable model of engagement, whereby artists, curators and commissioners might leave something behind that could not have been anticipated from the outset. As an accumulation of multiple artistic positions, modes of engagement and public moments of a durational eventful process, the site for art in public space moves beyond its immediate situated context to take account of time as the necessary means for enabling the unexpected to occur, for a history to unfold and for art to connect with its immediate public constituency in a longer-term succession of continuously activated engagements.

Whereas the 1990s witnessed a growing perception that a coherent relationship between one single place and identity was possible, with site-specific art contributing to the more general 'cultural valorization of places as the locus of authentic experience

19 Clare Cumberlidge and Lucy Musgrave, 'Introduction', in: Clare Cumberlidge and Lucy Musgrave (eds.), *Design and Landscape for People: New Approaches to Renewal* (London: Thames & Hudson, 2007), 15. See also www.generalpublicagency.com.

and coherent sense of historical and personal identities',[20] subsequent theories have shown place to be an always temporary, evasive and open construct. Any place is a constellation of cohabited spaces: full of contestation, negotiation and instability. Never fixed, it is always hybrid, differential and mobile, where its multiple dimensions are brought to bear on the social, as much as it is formed out of extant social processes and external forces.[21] Durational commissioning practice purports that the identity of a place, and for art that engages with public space, will always remain in flux; where place emerges, submerges and re-emerges through social praxis, as an evolving and ever-changing multitude of identities. As Tim Cresswell writes, place is 'the raw material for a creative production of identity rather than an *a priori* label of identity. As such, place provides the conditions of possibility for creative social practice' without being bound by notions of rootedness, authentic origins or permanence.[22]

From the Temporary to the Permanent

For the encounter with public art to be understood as a durational process evolving through spatial practice, rather than a momentary encounter with its objecthood, it must resist its role as something productive, holistic or beneficial in the short term. Instead, through an understanding of the role of curating art for its constituted public and its effects as a durational praxis, curating might take account of how its engagement with ideas of subjectivity and citizenship are made manifest over time. The complexities of artistic co-production and of public space can be seen as something actualized and given form, in which the public is understood as something produced as much as it can produce through a logical succession of continuity and transformativity rather than discontinuity in time and place.[23]

20 Kwon, *One Place After Another*, op. cit. (note 2), 52.
21 For recent close readings of the theorization of space and place see D. Massey, *For Space* (London: Sage, 2005) and T. Cresswell, *Place: A Short Introduction* (London: Blackwell Publishing, 2004).
22 T. Cresswell, 'The Genealogy of Place', in: Cresswell, *Place*, op. cit. (note 21), 39.
23 See Simon Sheikh, 'Publics and Post-Publics. ▸

Key to the sustainability of the curatorial remit for Beyond is the ability to remain 'mobile, [to] take care to be as open and flexible as possible'.[24] After nine years of mainly temporary interventions into the infrastructure of Leidsche Rijn, the artistic advisory team of Beyond is curating a series of permanent public art commissions at the site, which will be dispersed throughout a large park area in September 2009. The core idea is to create a sculpture park for the twenty-first century based on Michel Houellebecq's science fiction novel *Possibility of an Island* – an account of a jaded, middle-aged man looking for meaning in a dystopian island of the future.[25] The eponymous novel has been distributed to artists with the aim of evoking the kind of artworks that were to be commissioned for a sculpture park of the future.

While certain projects, initially intended as temporary, have become semi-permanent and found a sociocultural function in the new city extension, the shift towards permanent commissioning seems at odds with the original scenario and the interest in temporary events. This decision is about creating an adoptive practice for the future in relation to the other kinds of public art already in place there. The rationale for the permanent sculpture park is not only concerned with bringing a conclusion to Beyond, but also with making a claim on its own effective permanency as having left something monumental behind.

The initial idea of curating an endless event purports that art and its public are dialogically entwined, where temporariness is sustained in parallel with becoming communities. As collective memory and ephemerality are reliably forgetful, it is doubtful whether Beyond will be remembered for its open-ended duration, its temporariness and its cumulative programme or more for its decision to deploy a more conventional approach to permanent

▸ The Production of the Social', *Open* 14, *Art as a Public Issue* (2008), 28.

24 T. van Gestel, 'Events as a Means rather Than an End', in: *Events. SKOR Art projects Part 4* (Amsterdam: SKOR, 2007), unpaginated.

25 Michael Houellebecq, *Possibility of an Island* (London: Weidenfeld & Nicolson, 2005).

public sculpture. As its main durational 'event as a means' comes to an end, it might be worth asking if Beyond is still awaiting its expectant audience – a future public for its art park of the future.[26] As a commissioning model, its legacy will not reside in any temporary or permanent artwork, but in its long-term efficacy and what it has left behind; not in art but in its potentiality as a prospective model in years to come. To what extent it will be adapted in subsequent commissioning policies, in Leidsche Rijn and beyond, is where its most transformative novel will be written.

26 Van Gestel, 'Events as a Means', op. cit. (note 24).

BARBARA VISSER

Amsterdam, 29 May 2006

Dear Gerrit,

A few weeks ago, my father quit his job at the Rietveld-Schröder House. Having worked as an engineer for the National Building Society all his life, he considered the house you've designed for and with Truus Schröder-Schräder an appropriate environment for a post-career volunteer job, where he could make use of his love for architecture and design, guiding groups of tourists around the house.

He explained his resignation by giving just one reason. He said that the ride to Utrecht from his home in Almere is too long if it is merely made to tell the same story every time.

My father did however, enjoy the questions of the visitors, he told me. He's kept a record of the ones he could not answer, to look for the information later, at a moment when the visitors themselves were already on their way back to Tokyo, or busy seeing another important European sight.

In most of the literature about the Rietveld-Schröder house, as romanticized as that may sometimes be, your relationship to Mrs Schröder is described in technical terms.

It's probably unprofessional to consider personal circumstances when reviewing a designers' work. But isn't the Rietveld-Schröder house the ultimate metaphor of the radical changes in your personal life at the time? The idea of transformation is expressed most clearly in the changeable structure inside; rooms can change size and shape, appear and disappear according to their function and the needs of the inhabitant at any moment of the day or night. It's tempting to think of the 'hidden' storage places in terms of psychological as well as practical signs.

The big changes you've made in your personal life may have been quite a scandal at the time.

Now, in the 21st century, it's common practice that people change habits, houses, jobs, spouses, age, offspring, language, looks, foods and timezones within days, hours, sometimes minutes.

What remains a mystery to me is why a lot of the ideas as formulated in the Rietveld-Schröder house – so clearly ahead of their time – have become relics; things to be visited and looked at in retrospective admiration, instead of having naturally developed into general parameters for building in the 20th century.

The paradox of the time I am writing you from, is that one is expected to have conflicting personalities; on the one hand be a stable and decisive person, and at the same time be able to adapt to an infinite range of social and professional situations. The form of living for a person under these needs to be further developed, starting from your heritage that, unjustly so, has remained unique.

Yours,

Barbara Visser

HOW TO LIVE?

144

The central assignment in the competition inviting designs for a 'VIP home for Leidsche Rijn' left nothing to the imagination: design a *landmark* for Leidsche Rijn, 'a house that gives the site a certain weight, a house with some special significance, or a house for an unusual person. An example that comes to mind is the Rietveld-Schröder House in Utrecht, which has been designated a UNESCO monument because its inhabitant gave Rietveld the opportunity to make this house into a radical statement about housing and living together.'

Although the Rietveld-Schröder House is an excellent example of the combination of ideals, architecture and personal circumstances, the analogy with a future architectural place of pilgrimage on the outskirts of Utrecht is flawed in several respects. But that did not stop me from revisiting the Rietveld-Schröder House for the first time in many years and listening to what the guide had to say. The guide, who was not entirely coincidentally my own father, turned out to have just decided to stop showing visitors round the house.

In Rietveld's design, rooms appear and disappear with the use of movable partitions. This makes the house into an environment that can change in response to the everyday fluctuations in residents' living and working conditions. That the house adjusts to those who live in it instead of the other way around is a principle that will appeal to everyone's imagination and is frequently presented as a theoretical possibility in architecture; in fact, however, few examples exist.

Moving forward to the twenty-first century, in which individuals are confronted with changes on the personal and professional level on a bigger scale than in 1924, my entry constituted a kind of sequel: a house that can undergo transformations of scale. And although it could never provide the solution for all living situations, it is a statement that, in contrast to the static architecture of *Vinex* estates, could serve as a model for something that, in the right place and at the right time, could lead to different views about living and working.

My first-round proposal consisted of reflections based on my own housing history, which seems rather typical of the spirit of the 1960s and 1970s. I wrote an essay linking living space to a chaotic family life, with a lack of direction, reinforced by the spirit of the age, that did not eventually lead to anything very interesting, let alone to the happiness of those concerned. A striking element was the literal reversal of the idea of the 'parental home': parents stumbling into the future with their new partners while their children stayed behind among the brown and orange household furniture.

The text also included a letter from me to Gerrit Rietveld, explaining that my father had given up his job as guide in the Rietveld-Schröder House because he had become thoroughly tired of telling the same story again and again in a historical peepshow that had so clearly been designed for people to live and work to the full. Now converted into a museum, the house has become a setting in which ostensibly formal aspects have to be reanimated with anecdotes.

When the tangible results of living ideals are accorded the status of UNESCO monuments, something must surely have gone wrong somewhere. My first premise was that I wanted to develop an idea that would never achieve a definitive state, because the house's shape would always be related to a moment in the user's life. The House had to be based on a principle of mutability.

Vinex houses project an air of temporary final destinations. They focus on practical matters: the car parked right outside the house and enough bedrooms for 1.9 children. There is a total separation between living and working. Is that why so many people working in the cultural sector have such disdain for these dormitory towns? The cultural elite assume that 'people like that' come home, have dinner, watch TV and go to bed, and above all lead Very Empty Lives. It is true that the range of cultural opportunities on offer, the social network, and the possibility of dropping into a department store at the merest whim is limited, but it is highly debatable how much is to be gained by having these things within reach 24 hours a day. When

my best friend and I moved into the same apartment building, we stopped inviting each other to dinner; it no longer seemed necessary, now that we were so close. It is mainly the *idea* of the city centre that is so inspiring.

In the autumn of 2005, art historian Lisette Lagnado arrived from São Paulo, Brazil in the bleak and windy Leidsche Rijn, where Beyond had just opened the event 'Pursuit of Happiness'. She was welcomed by a friendly student attendant, blue with cold and encased in a thick sweater, who was stationed with his booklet in the specially modified barn on the site.

Many art 'consumers' see the psychological distance between the city centre and provincial small towns as unbridgeable, but Lagnado views the distance from Amsterdam to Leidsche Rijn much like a trip to a different part of São Paulo. The true cosmopolitan makes the switch effortlessly: from a metropolis where attempts to count the population produce results that differ by several millions to a *Vinex* location where the families have been counted down to the last half child.

With her own major project at the back of her mind, entitled 'How to Live Together', Lagnado was drawn to the exhibition's title, which in all its topicality nonetheless evoked the naive world of the previous generation: for there is no difference between pre 9/11 and post 9/11 in art: only the visitor's gaze has changed.

Lagnado leaves the picturesque city in which the artists live, and crosses a muddy field to reach Stanley Brouwn's pavilion, which has just been completed. The story goes that the artist Brouwn explained what he had in mind by placing two matchsticks on the table at right angles, one on the top of the other, after which it was up to Bertus Mulder, the former right-hand man of – there's that name again – Gerrit Rietveld, to show that this vision could be converted into a viable building. Which he did!

The work being shown in the pavilion, *Two Projections*, is one that I created especially for this occasion. It consists of a sound recording and a series of slides projected in the form of a video. In

the slide projection, I try to portray my grandmother through her eternally modern furniture. She designed a great deal of it herself, and over the years these structures gradually encased her like a suit of armour. Two underlying questions: Can good taste protect someone from the dangers lurking in the outside world? And how conservative, really, is the 'modern' gaze?

Like many portraits, it became a double portrait in which maker and sitter merge: *Two Projections*. And although the family relationship is not mentioned, certain matters are raised that an 89-year-old woman would be unlikely to discuss with a stranger: her mother, who vanished to Cuba with the Cuban ambassador when her daughter was just one year old, her Jewish father who was deported to a death camp in the Second World War, and the observation that as a young girl, she took more interest in art than in sex.

When Lisette Lagnado asked if she could show both *Two Projections* and the animated film Transformation House II as part of her biennale on the theme of 'How to Live Together', it prompted me to ask myself whether these personal tales could have any significance for an audience in Latin America. And does my work not rather revolve around the question of 'how to live'?

How to live. In any case, not on a *Vinex* estate. Far preferable is the priceless historic centre of a city. Is it the daily unconscious brushes with history, the distances that are so easy to cycle, or the tourists whose presence constantly emphasizes all the attractions on your doorstep? São Paulo, in every respect the complete opposite of a *Vinex* estate, does not have any of the qualities we attribute to our little canals. Perhaps it is really about something else. In Brazil, planners opted for a twentieth-century vision that admittedly got out of hand. Vertical growth on this scale, alongside the inevitable expansion in a horizontal direction, is inconceivable in the Netherlands. The plans in Leidsche Rijn for a 262-m-high phallus named after the eighteenth-century novelist Belle van Zuylen is the exception that proves the rule; it is the vertical dream translated

into a symbol, and certainly not intended as an idea for a way of life. The suburban formula, complete with its standard gardens and garages, is spelled out horizontally. And at ground level.

So my entry for the architecture competition 'House for Sale' did not make propaganda based on a metropolitan point of view, but instead admitted a kind of naiveté that only an artist can get away with. In the words of one friend: 'What you did with your Transformation House is really to make a proposal in which people's choices would be less harmful to their surroundings, with references to the social environment and the family, whether intact or shattered.'

An aspect that has scarcely been explored to date, which would link up extremely well both to the Transformation House and the *Vinex* location, is a more ecological approach to living. That too has always been dismissed as marginal, but it no longer attracts immediate derision, now that it turns out to have become an asset. Even that status symbol, the Belle van Zuylen tower, is proudly displayed on the website, complete with green energy solutions.

When we launched a joint venture, as artists whose studios were located in the same building, to generate our own energy using solar panels on the roof, we discovered that the roof had already been promised to an energy supplier for precisely that purpose. The individual member of society thinking up his own ideas is seen as a bit of a *schlemiel*. It's the model based on practicalities that wins again: top-down solutions, assuring economic gain with large quantities, uniformity trumping diversity: the *Vinex* model. But when the *Vinex* sites turn into large green energy-efficient neighbourhoods, it'll suddenly be totally cool to live there. The poverty of the monoculture, the lack of social and cultural diversity, will all be easily outweighed by the aura of clean energy and future-oriented thinking. And mark my words, the tourists will soon be flocking there, too, to look at the windmills.

STAGING THE UPSTAGED

67

THE ARTISTIC INTERVENTIONS OF BEYOND IN LEIDSCHE RIJN

DOMENIEK RUYTERS

Scenario

From the very beginning, Beyond was ambitious, if not overambitious. The original declaration of 2001, written by architecture historian and member of the Beyond Project Team Bernard Colenbrander, had traits of a manifesto and showed this ambition in no uncertain terms.[1] Instead of sculptures for squares and parks, Leidsche Rijn was to be endowed with public art that would 'boost urban processes'.[2] It would have a lasting influence on every aspect of the building process, even after the art itself had disappeared from view again. If there was going to be art on view, that is. For this is perhaps the most peculiar characteristic of Beyond: the low value apparently placed on artistic display. The Beyond art project was launched as an action and research programme revolving around fieldwork – a return to basics with a strong focus on urban development processes.

It was clear from the original declaration that Beyond wanted to transcend established patterns of public art. The size and time scale of the Leidsche Rijn housing development demanded a different approach than usual: more flexibility was needed and an ability to respond to new developments. The aim was to claim a territory that had not yet been divided among the various property developers who had been buying up plots for Leidsche Rijn. The territory Beyond wanted to claim was not necessarily an actual space consisting of vacant building plots, but first and foremost a mental space where artists, architects and urban developers could come together in a fraternal atmosphere. Colenbrander explains: 'Today's culture undeniably shows a trend towards multidisciplinary solutions

1 The Project Team, as it was then still called, also included Jan van Grunsven, visual artist and architect; Mariette Dölle, project co-ordinator at Utrecht City Council; Tom van Gestel and Govert Grosfeld, both project co-ordinators at the Foundation for Art and Public Space (SKOR) in Amsterdam, and chairman Peter Kuenzli, director of the Leidsche Rijn Project Bureau.
2 Bernard Colenbrander, 'Beyond — Leidsche Rijn: The VINEX Assignment for Art' (Utrecht, 2001).

and a broadening of the formal and intrinsic aspects of art at the cost of the autonomy traditionally associated with works of art. This was illustrated at "Documenta X", held in Kassel in 1997, where art blended with social commentary, politics and environmental planning. Possibly it was architects and photographers rather than artists who shone most at this event.'

Architects become artists and artists become architects. For Beyond this was a logical development: 'When the meaning of the cultural action is thought more important than the form of "the thing" itself, an obvious consequence is that artists alter their methods.' Social interaction was the main aim. 'Art looks to architecture, architecture looks to art and they both look to the world around them.' Instead of celebrating the autonomy of art, the programme involved itself with what is known in Dutch politics as 'the makability of social reality', that is bringing about social change through government action. As Colenbrander stresses: 'Today's culture is not about beautiful objects but about motifs, ideas and their exchange, and about receptivity to the unfamiliar.'

Militant

For all the setbacks you can expect to accompany a large-scale art programme such as Beyond and the changes that have occurred since it was set up, Beyond's output has remained remarkably close to the original principles. It steadily realized a number of smaller programmes with catchy names such as Action Research, *Parasites*, White Spots, Artists' Houses and Looping.

What comes through most strongly in these programmes is Beyond's critical stance towards Leidsche Rijn. Its clear reservations about the *Vinex* suburb can be gleaned from almost all of the projects that have been realized. From the very start it seems that Beyond felt that its most important task was to transform Leidsche Rijn from a languid garden-city characterized by quiet emptiness and an impressive absence of any form of urban dynamism into a quasi-metropolitan theatre. In the original

declaration Colenbrander literally asks: 'Can Leidsche Rijn work its way up to becoming a genuine metropolis, if the spirits so decide?' He decides enthusiastically: 'Yes, it can!'. Leidsche Rijn, too, can become a city, and a full player in what Colenbrander calls the 'Randstad Metropolis'. Whether this corresponds to the wishes of the newly arrived occupants, who moved here to get away from the hustle and bustle of the inner city, seems beside the point.

When listing the projects that were realized in the early years, you get the strong impression that behind these works was a cultural activist whose bold offensive strategy included clever infiltrations, strategic interventions and even direct land occupations. All this was presented through the smooth voice of a well-adjusted communication department with the somewhat mysterious name of Looping. The aim was to free the *Vinex* district as quickly as possible of its *Vinex* image and to endow it with so-called 'alternative forms of urbanism'.

Beyond's first project in Leidsche Rijn – the placing of a series of seats by Dennis Adams in the Langerak and Parkwijk neighbourhoods – is a typical example of this somewhat intrusive strategy: the triple seats, bright fluorescent orange and fixed to a concrete base, are replicas of the seats assigned to the so-called Bunnikside supporters of FC Utrecht at Galgenwaard Stadium. The seats were positioned randomly across the area in a rather confrontational manner and without taking much notice of the local surroundings. Some of the benches faced a wall, others were positioned behind a fence. In each case the main consideration was the symbolic, cultural meaning of the seats and not how practical they were. The underlying idea was to encourage new residents in the area to form a community modelled on the urban football culture of Bunnikside.[3] From the outside, however, the benches look more like harbingers of a cultural programme designed to be conspicuous in the area and to provoke reactions. The orderly housing estate was to be given an injection of urbanism, a dose of city chaos that was meant to foreshadow the cultural invasion awaiting the area.

3 Brochure Beyond, Utrecht 2005.

The project that followed had a similarly militant undertone, although it was considerably less intimidating and even had a hint of romanticism about it. The *LAND* project by the Danish artists' collective N55 literally consisted of taking possession of a patch of ground in the Terwijde district and making this into a free zone following the example of Hakim Bey's Temporary Autonomous Zone (TAZ – highly popular in the 1990s with squatters, autonomists and antiglobalists). In an area where every square centimetre of land belongs to property developers, N55 wanted to establish a small sanctuary that was 'freely accessible to all and could be used by the community'. The aim was to add an 'unpredictable element to a planned environment'.[4] A dome-shaped hill marked the small plot of land and a manual explained the ideas behind the project.

The cultural invasion properly took hold in the summer of 2003 when Beyond organized 'Parasites Paradise', an event that involved the arrival of a small battalion of so-called *parasites* on a vacant plot at the entrance to the Langerak and Parkwijk districts. These mobile structures, which looked as if they belonged to a disorderly troop of nomads, were examples of flexible, experimental architecture, built by artists and architects. They demonstrated alternative ways of living, working and creating a community. For two months the site featured a mobile restaurant, a mini cinema and a mobile farm by Atelier Van Lieshout, and a multistorey campsite where people could spend the night.

'Parasites Paradise' showed residents of Leidsche Rijn what Beyond was about. It communicated Beyond's ultimate aspiration to have 'a society that is open to the unexpected, encourages people to meet and recognize each other, accepts newcomers and promotes an atmosphere in which communities welcome outside influences.'[5] As the brochure stated, the event was 'a plea for the unstaged, the unplanned and the unusual', all of which were in seriously short supply in the young urban quarter ruled by order and regularity.[6]

4 *LAND*, manual N55, 2003.
5 Colenbrander, 'Beyond', op. cit. (note 2).
6 Brochure Beyond, Utrecht 2005.

Metropolis?

The crucial question is why Beyond was so eager to transform Leidsche Rijn into a lively metropolis with numerous 'alternative' urban functions? Why could the new, city-sized housing development in the polders between Utrecht and Vleuten not just be the typical kind of dormitory suburb that most *Vinex* locations are destined to be? Why all this cultural zeal, which was undoubtedly well-intentioned but came across as slightly aggressive? The explanation seems to lie in the fact that the dormitory suburb (and its successor, the *Vinex* location) has always had a very negative image, as we know from in-depth research into this subject by Dutch cultural historian David Hamers. In his book Tijd voor Suburbia (time for suburbia) he describes how for more than 50 years the so-called garden cities have suffered a bad reputation because of their monotonous architecture and homogeneous population. This bias exists especially among members of the political and cultural elite. It was commonly believed that these new housing developments provided the ideal home for the white middle classes, epitomized by the self-made man who makes every effort to lead a dull life.

On the basis of Hamers's characterization you might expect this negative image also to have dominated Beyond's Artistic Team. But when you read Ivan Nio's essay in the book that accompanied *Parasite Paradise*, a different picture emerges.[7] According to Nio, the *Vinex* developments that have been built in the Netherlands since the 1990s are neither architecturally uniform nor inhabited by a single social class. They attract people from all layers of society, from workmen to middle-class professionals, and from a range of nationalities. In Nio's opinion, the problem with a housing project such as Leidsche Rijn lies not in the absence of urban potential, but

7 Ivan Nio, 'Van clustering naar kleinschaligheid: flexibele en tijdelijke voorzieningen in Leidsche Rijn', in: Liesbeth Melis (ed.), Parasite Paradise. *Pleidooi voor tijdelijke architectuur en flexibele stedenbouw* (Rotterdam/Amsterdam: NAi Publishers/SKOR, 2003), 20–29.

in the inadequate representation thereof in the provision of local facilities. All too often policymakers continue to treat *Vinex* locations as strictly dormitory towns adjoining the old cities which provide the amenities needed. Nio, on the other hand, believes that they should be thought of as 'network cities' and as centres in their own right. It may be true that many residents leave during the day, but people still like to have a good range of urban amenities in the vicinity of their homes.

Nio's text shows that Beyond was mainly concerned with challenging the way *Vinex* was perceived by policymakers and the public, and possibly even by the Artistic Team itself. It was essential that everyone would realize that Leidsche Rijn needed urban facilities since residents were demanding them. To quote the original declaration: 'Beyond seeks to contribute to identifying the multifaceted meaning of the term urbanization [in this area].'[8]

After 2003, Beyond continued with this policy of criticizing the planning process and offering alternatives, though not as aggressively as before. The Action Research project attracted various artists who, while staying in the *parasite Nomads in Residence/No. 19* (designed by Bik Van der Pol and Korteknie/ Stuhlmacher Architecten), looked for facilities that were not provided in the area, and then gradually devised special programmes to fill the gaps. To give an example: in the course of her stay, which lasted several weeks, Apolonija Sustersic rearranged the *parasite* so that it could be used as a cinema/studio. A programme of children's films was then shown on Wednesday and Saturday afternoons and in addition to this a special programme of public discussions was organized at which urban developers and other experts were asked to comment on gaps in the plans.

Service Oriented

With an art practice that is geared towards expressing criticism as well as providing a service, with temporary projects at the heart of society, its interest in architectural processes and its need for

8 Colenbrander, 'Beyond', op. cit. (note 2).

debate, Beyond cannot be seen outside the wider context of what happened in art in the 1990s. These years generated a form of art that concerned itself more with the process and the functional environment, than with the objective final product. These were the years of Relational Aesthetics, which proposed that art should be seen as an interaction with the public and be judged on its good intentions.[9] The 1990s were, moreover, a time of multidisciplinary productions and there was a predilection for 'anti-specialism'. Outsiders seemed sexier than the visual artists themselves, and managers were called upon to show how creative they were.[10]

After the authority of 'white cube' art had been demolished by 1980s' postmodernism, the 1990s were in fact a period when artists were trying hard to find a new relevance. To an extent the search for a new orientation was guided by public art, which is by definition the stage on which the social relevance of art is judged. In the political sphere, Lily van Ginneken had been working since 1990 towards a new policy for public art. Inspired by a critical essay of 1990, in which Cor Blok argued in favour of putting a freeze on public art, Van Ginneken refused to continue along the same old lines, choosing instead to organize events and debates which involved artists going on field trips around cities, regardless of the outcome.[11]

Another important factor in the development towards a more socially integrated art was the 'Sonsbeek 93' exhibition in Arnhem,

9. For a recent review of Relational Aesthetics and its effect on Dutch art see: Erik Hagoort, *Goede bedoelingen. Over het beoordelen van ontmoetingskunst* (Amsterdam: Fonds BKVB, 2005).
10. In the mid-1990s the Hague centre for art and architecture Stroom Den Haag organized several lecture evenings with mangers who gave their view of creativity.
11. Cor Blok, 'De geloofwaardigheid van beeldende kunst in de openbare ruimte', Archis 12 (1990), 8-17. Famous large-scale projects of Stroom Den Haag include: 'The Campaign' (1990-1991), 'The Guinea Curve' (1992) and 'The Seventh Museum' (1994). An overview can be found in: Lily van Ginneken, *Kunst in de Openbare Ruimte '90-'98* (The Hague: Stroom, 1998).

curated by the American curator Valérie Smith and one of the most maligned episodes in the history of this large sculpture event. While in the previous exhibition of 1986 art had both literally and metaphorically eroded itself into an empty shell – 'art as skin' was the motto – Smith selected works of art with the aim of seeking contact with and even confronting society. She was intent on a 'multicultural' approach, which reflected changes in society both at a micro and macro level, calling Sonsbeek a 'platform' where questions about 'individual, multicultural and public art could be discussed'.[12]

Thanks to the traditional percentage regulations which ensure that that there is a continuous stream of money, the Netherlands were at the forefront of this development towards a more socially integrated art for public spaces. Utrecht in particular had in the past been the scene of large-scale experiments with integrated forms of art, inviting artists to make a critical contribution to the design process of new housing developments. When plans got underway for the housing development of Lunetten, realized in the decade 1974-1984, provisions were made early on for the role of art and this resulted in a close collaboration between artists, urban developers and architects at the stage of realization.[13] Beyond can be regarded as the successor to Lunetten, which partly at the initiative of the ministry was presented as an ideal model for integrated art practice. One important difference with the past is the temporary aspect of the projects realized by Beyond. Beyond started from the conviction that a city under construction, with the uncertainties brought by adhering to a building scheme that extends over 15 years or more, is not compatible with permanent art.

12 Valérie Smith, 'Aantekeningen bij Sonsbeek 93', in: Jan Brand et al. (eds.), *Sonsbeek 93* (Arnhem: Stichting Sonsbeek, 1993), 7-10.
13 For a critical evaluation of Lunetten see: Camiel van Winkel, *Moderne leegte. Over kunst en openbaarheid* (Nijmegen: Sun, 1999), 115-167.

The Late Years

As intended, Beyond has generated a great deal of discussion through various temporary programmes. A few (temporary) provisions have been realized, including showpiece *parasites* such as Shigeru Ban's *Paper Dome* and the splendid exhibition pavilion by Stanley Brouwn. There has been much interest among professionals, nationally as well as internationally, in the experiment with art that intervenes in the building phase of a neighbourhood. But the first tens of thousands of residents have not really warmed to the experiments. Sometimes they were found unacceptably extravagant for an area with more urgent social and cultural needs. The practical realization also caused problems at times. Some of the more ambitious integral projects did not go smoothly, and others had to be cancelled, for example the car wash areas ('Waplas'); designs for these were produced but no developers were prepared to install them.

The main problem that Beyond has encountered is the negative image of new housing developments. Despite fierce attempts to change these notions they have carried through to the present. This seems true particularly of the artists who took part in Beyond and who, while staying in the dormitory suburb amid grassy meadows and pram-pushing mothers, were plagued by doubts about the meaning of art in a location as anonymous as a housing development under construction.[14] This scepticism even comes to the fore in several of the projects that were realized. Sophie Hope, for example, one of the artists invited to take part in the Action Research programme, visited Leidsche Rijn and decided to design a theme park showing in no uncertain terms her own surprised reaction to life in a *Vinex* location. In Hope's 'archaeological' theme park *Back to the Present* – a look at the present from a future perspective – Leidsche Rijn residents were portrayed as museum curiosities featuring a typical living room, an SUV, clothing and food.

14 In conversations with the author (March 2009), both Apolonija Šušteršič and Barbara Visser expressed doubts about the usefulness of having an art programme for new housing developments.

The Puerto Rican artist Jesús Bubu Negrón similarly made little attempt to hide his antipathy to new housing developments: during his stay in the district of Terwijde he transformed his residence into a 'bicycle repair workshop' where local residents could have their bicycles covered with reflective tape. His project culminated in a nocturnal bicycle escape by a large crowd of cultural 'insiders' who fled the area to return to the cultural haven of Amsterdam, where Négron had an exhibition at the time.

The cultural divide between the artistic community and Leidsche Rijn seemed difficult to bridge. This was particularly noticeable during the major 'Pursuit of Happiness' event that was held in and around the freshly opened pavilion by Stanley Brouwn and which included contributions by 25 artists from the Netherlands and elsewhere. The event was presented as a 'poetic presentation of visual art about the pursuit of dreams in a young area', but it was mostly a sceptical analysis of the idealized picture of life in the new housing estate. The documentary *Celebration* showed the failure of the dream city named after and created by Disney; Arnout Mik produced a video in which the new housing estate is compared to a war zone for children, and Barbara Visser contributed a magnificent portrait of an old lady whom she ambiguously presents as a pioneer of 'Good Living' and someone who distances herself from the idea of a utopian state and other modernist ideals. A thought-provoking highlight of 'Pursuit of Happiness' was the piece in the farmyard by Monica Bonvicini involving a piece of land with a couple of lampposts whose function was unclear. Bonvicini claimed the piece of land by half knocking over one of the lampposts with a car. She then wrapped the damaged lampposts and several other posts with bundles of lights. The work was an intriguing combination of beauty and violence and can be understood as a protest against the strict, middle-class ethic of the new housing estate.

More Than One Beyond

Beyond is not just one thing. In comparison with the critical attitude of the first period, when Beyond aimed high and believed it could play a part in transforming the dormitory suburb into a vibrant centre, it has adopted a much more modest policy since 2006. With the exception of an artists' house that was planned in 2001 and will soon be completed, there have been no more large-scale experiments. After the wild years in which Beyond attracted international attention with its attempts to give art a role in the development of the slowly expanding urban fabric, the programme has in recent years returned to the more familiar, slightly marginal role of public art in the purely artistic discourse on the periphery of urban planning. This is symbolized by the most important work of recent years, *Roulette*, by the German artist Manfred Pernice. Its location is a roundabout on the outer edge of Leidsche Rijn, right by the A2 motorway. Instead of continuing to challenge the relationship with residents and policymakers in a duel that focuses on social reform, Pernice opts for a conciliating, more art-focused gesture: research into the functions of public sculpture. Pernice removes old sculptures from their plinths in the city and arranges them in subtly varying constellations on specially designed plinths placed on the roundabout. The work examines how these works interact with each other in a different environment, in a sense serving as a metaphor for Leidsche Rijn itself, where people who used to live in the old city also have to find ways of relating to each other in a new environment.

With *Roulette*, Beyond announces the final, most monumental phase in its existence, which will be completed in the summer of 2009 when several large sculptures will be installed in the Leidsche Rijn Park designed by West 8. The final project marks the end of the Leidsche Rijn housing development; the building site has been turned into a city and the time has come to make one last gesture. The choice in favour of monumental sculptures reflects changed ideas

about public art. Large-scale social experiments are no longer the thing of the moment – no one mentions integral art projects any more. Suddenly people everywhere are looking for alternative forms of public representation, different from the interactive models of the Relational Aesthetics era. Both in the Netherlands and abroad the question being asked is whether classical monuments can be a factor in the desirable processes of identity and community formation. Beyond intervenes in the discussion with, among other things, a pair of impressive bronze car wrecks placed in the middle of a path. The over-life-size sculptures by Fernando Sanchez Castillo call up memories of the Paris uprisings: these works, and this is characteristic of the art of Beyond, do not offer the most optimistic look into the future of Leidsche Rijn. But they definitely are among the artistic highlights of the ten-year programme.

BARRICADE

FERNANDO SÁNCHEZ CASTILLO

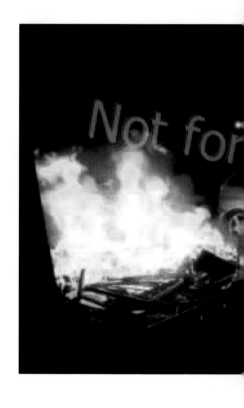

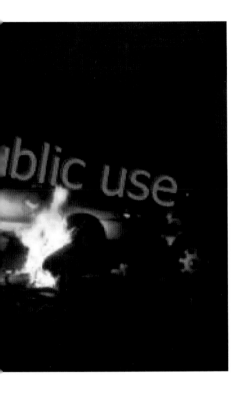

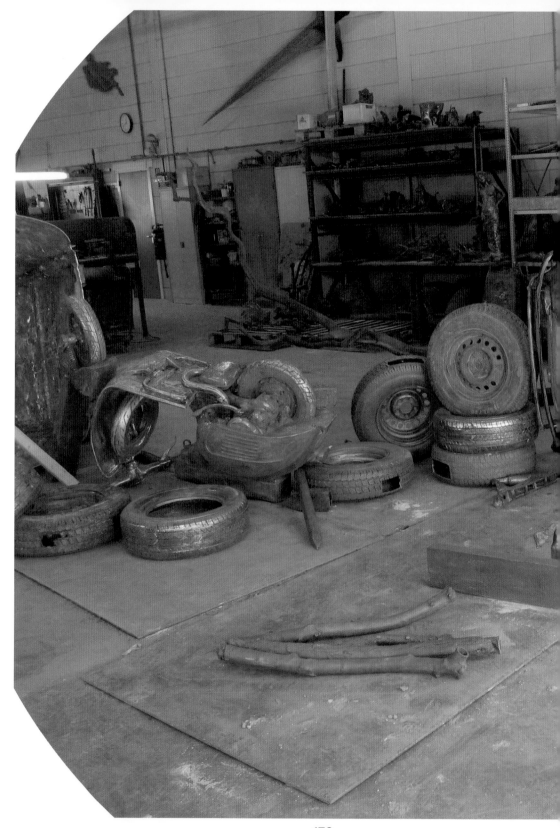

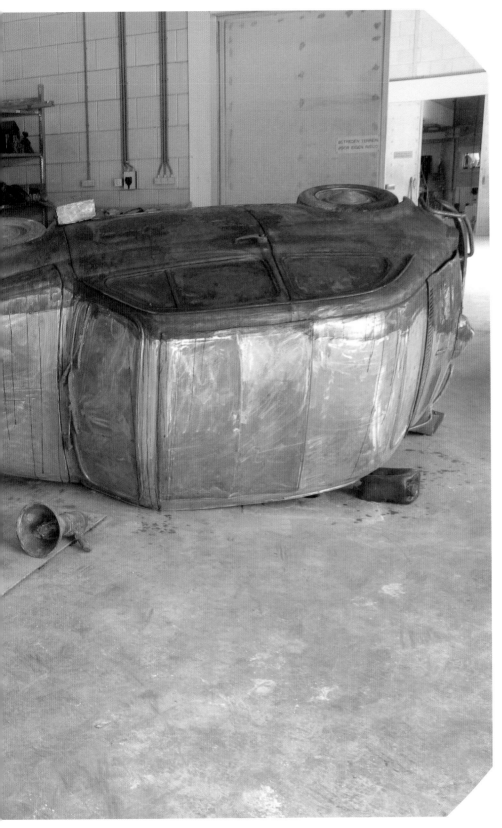

Fernando Sánchez Castillo

MARJOLEIN SPONSELEE

68

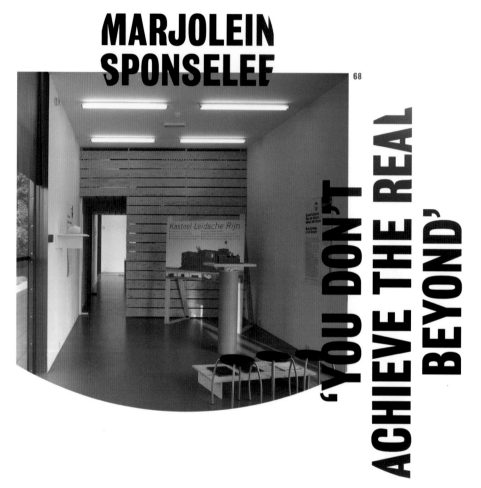

Kasteel Leidsche Rijn

'YOU DON'T ACHIEVE THE REAL BEYOND'

A CONVERSATION WITH WOUTER VANSTIPHOUT

Wouter Vanstiphout

Wouter Vanstiphout (Belgium, 1967) is an architectural historian. In 1994 he founded Crimson Architectural Historians with four colleagues and was involved with the master plan for Leidsche Rijn. He is a visiting professor at the Institut für Kunst und Architektur of the Akademie der bildenden Künste, Vienna, and is an advisory board member of SKOR.

Architectural historian Wouter Vanstiphout and his Crimson agency were involved in the first development phase of Leidsche Rijn. At the invitation of Rients Dijkstra, Crimson collaborated on a master plan for the largest *Vinex* district in the Netherlands in 1994.

The ambition was to do something different with the new neighbourhood, other than build new dwellings. But shortly before the greatest wave of building development since the 1950s began, it was evident that the government, through deregulation and the privatization of housing corporations, had parted with the most important tools it had to carry out urban development. The free-market sector and individual owner-occupied houses increasingly determined the image. Thinking in terms of collectivism and cohesion in urban planning came second to the individual, market forces and uncertainty. Within this new reality, Leidsche Rijn's urban designers conceived of a flexible plan based on coefficients. It was Crimson who worked mainly on this. Coefficients decide the density, spread, architectural control and concentration of the buildings, the level of interest in the architecture and the boundaries and transitions of the different zones.

Vanstiphout: 'We had to conceive of a new type of urban development within the dynamics of continuous negotiation. We could no longer assume a final, finished concept with which you have to convince everyone, but fixed one thing so that the rest could be left open. This meant an urban development that was extremely precise in what was important, such as the long straight line from Rijnkennemerlaan, or the park boundaries. You can then leave what happens in between to the developers, but they must stick to the formulated coefficient for this, like the density and spread of the

building has to be according to a certain norm. That was our way of creating urban planning that takes into account the immense uncertainty and limited powers you have as a planner. What is interesting is that the coefficients have all been adopted. They have been absorbed into officialdom and translated into rules and regulations. The contribution of Rients Dijkstra [principle of MAXWAN architects and chief designer of the master plan for Leidsche Rijn] was immense. It was his idea to cover the A2, a choice that will impact on Utrecht for hundreds of years. He said about this: "We have to bridge this motorway in some other way, otherwise you have a strip of land alongside the road that cannot be built on." The new neighbourhood would then have been as far from Utrecht as, for instance, Houten.'

Monotony

Crimson and Rients Dijkstra were involved at the very beginning with Leidsche Rijn, but quite quickly following the development phase didn't play a further role in the development of the area. By 1999 no-one from the early phase was working on Leidsche Rijn any longer. How does Vanstiphout look back on its design and development?

'I don't believe it did the plan any good that the original master planner, Rients Dijkstra, apart from designing a few bridges in Langerak, was no longer involved in any way with Leidsche Rijn. If you look at the details of the plans and the area plans it is risk-avoiding developer's house-building, dictated by the common denominator, with monotony cloaked in pseudo-diversity as a result. On the other hand, I'm aware of the resentful whining, typical of the misunderstood planner who's there at the very beginning, which probably comes to the fore from these remarks. So, to say something positive, there is a certain informality and casualness to the large-scale structure of the area, which differentiates it from the often rigid designs of other *Vinex* neighbourhoods, and which can probably be traced back to the master plan.

Regarding the bringing in of Beyond, you can be critical about this from an urban planning standpoint. It seems this was a deliberate strategic choice to incorporate real meaningful ideas for the area – the trying out of new things and thinking about what a new city extension such as this needs – into an art project. Art then becomes a kind of playground for substance, hipness and culture. But this is obviously a cover up, with art reduced to an alibi for the bureaucratization of urban planning. So if someone then says I want to do something very special, you say, do it in the form of an art project. It is a great shame that you then have a split between content and practice.'

Beyond?

Doesn't Beyond's questionable role lie in the way the project was organized, namely as part of local government structure? Did it become stuck in the culture of consensus?

'Being part of local government has advantages and disadvantages. In a location like this, it possibly has mainly advantages, as it makes the project more reliable, well embedded and the council is a good client for artists. But it is also a deadly embrace.
You can't be embedded and steer an autonomous course. As part of local government, Beyond falls under a process manager, a civil servant, a local council member and so on. Content and execution are then mixed up by people who are not content-oriented in the first place.

'At the time of Beyond, Crimson was involved with a reorganization project in Rotterdam, WiMBY [Welcome in My Backyard! www.wimby.nl], which was supposed to make the dreary working-class neighbourhood of Hoogvliet a better place to live in. We noticed in Hoogvliet that within the consensus culture no one objected to temporary things, and especially not art. But the minute you say we're really going to get involved, their faces cloud over. And then you've got to be tough and drive home your point, if any of

the ideas are going to survive. In Hoogvliet we were given the space to put content and making a difference uppermost, as we were autonomous and after seven years would be gone again. So we were able, for instance, to make the realization of the park and villa a make-or-break case. With a project team embedded in local government, the situation is different. Then the process becomes the ultimate goal, and you can perhaps do things that are interesting on a temporary basis, but you don't achieve the real beyond . . .

'The title Beyond has actually something very strange about it. It is a word Rem Koolhaas used in relation to urban planning and architecture. He believes that with every project there is always a stage where you have to "hammer home". Only that is precisely what people didn't do in Leidsche Rijn and I believe the Beyond project played a crucial role here. Instead of looking up the urban design interpretation of "beyond", an art project was started with the name Beyond. That is cunning, but cynical in the long run, as art by definition is obviously a "beyond". Within art that isn't a quality. From a societal viewpoint, art already has a mandate to be "beyond". Moreover, you could say that this fantastic mandate to be autonomous which art as one of the few disciplines has, is undermined the moment it's used for all kinds of social or building problems.'

Dynamics

Similar to the master plan for Leidsche Rijn, a flexible agenda was chosen for Beyond, in which future developments were outlined but not laid down. Bearing in mind the government's limited influence, is it in fact the case that Beyond can only realize something in those areas where the local council still has a say. So not in the residential neighbourhoods but only in the remaining public spaces and parks?

'There are different types of remaining spaces and you could say that the council also decides where these are situated. When we made the coefficients for the master plan, there was the matter of a

certain backing off by the council; local government had to rethink its position in relation to the project developers. For a moment this produced an interesting complex situation, out of which many innovative urban development methods arose, but after that it got completely out of hand. If you have the council behind you as urban planner, then the council has to say to the marketplace: you can build this block of flats or those dwellings but only if the architecture is of a high calibre, if the public space meets this same standard, if the ground floor of a building has public amenities, and so on. The council should say: "If you want to build 400 houses here then there should also be an artist's residence, otherwise you can't build them." That's the way it should be. But the deregulation process has gone way too far. It's a shame, but that is a force which is outside visual art. And that is precisely the problem: the visual arts say we'll jump into the centre of that force, but ultimately they remain on the edge. The naivety shown in the discussion about art in public spaces has naturally been immense. It is only now that we've woken up.'

Generating Urbanism

At the time Beyond articulated its objective as 'stimulating and attracting an international and urban cultural climate in Leidsche Rijn, in which particular attention was given to art projects that fit in with spatial development planning and interacting about these with citizens and interested parties'. Is this a feasible remit for art? Did Beyond succeed in this?

'These are very many different things. It's interesting that the visual arts are used to make a non-frumpish, experimental, pioneering type statement, which perhaps creates certain expectations among the people that go and live there. That it isn't somewhere with a purely consumer, dull suburban atmosphere where they're going, but a place where things happen, where there's a kind of urbanism. For no matter how you slice it, you associate art and artists immediately with urbanism.

What was great about Beyond was the exhibition 'Parasite

Paradise', in which a situation was created whereby you thought, this is really something, Leidsche Rijn has started. 'Parasite Paradise' had that urban feel. The embedding within a local council body, however, implies the promise that this kind of drive continues and isn't limited to one event. It is disappointing that in the end you wind up with a series of autonomous sculptures in a park. So, as far as I'm concerned, you could describe the first half of Beyond unreservedly as fantastic. But this makes the final results all the more disappointing. That a project such as Wapla is not going to happen is a real shame, as it meets everything you need: it creates a kind of focal point for the neighbourhood, a place where people run into each other. I feel it would absolutely have been used. Looked at from an urban development perspective, I think Beyond probably delivered a lot for Leidsche Rijn. But whether it has delivered anything for itself or visual art remains to be seen. It doesn't automatically follow that because Beyond was good for Leidsche Rijn, Leidsche Rijn was also good for art. There were obviously a few important artists involved with Beyond, but within that immense web of ideas they had to get involved with, didn't they simple do their own thing in the long run? Are those clever words from the plan also reflected in the works? Is it an important project for the art history of recent times? That is the crucial question. Because even if the project hadn't attracted anybody and was a financial disaster, if it had produced one good work, then in my opinion it was successful.'

About the Authors

Bik Van der Pol, is the collective working name used by artists Liesbeth Bik and Jos van der Pol since 1995. Bik Van der Pol explores the potential of art to generate and transmit knowledge, and studies methods that can be used to activate situations and create platforms for collective activities. For Beyond they teamed up with Korteknie Stuhlmacher Architects to produce the mobile studio *Nomads in Residence/No. 19*. This working and living space is intended as a temporary residence for artists, writers and researchers who are working in Leidsche Rijn as part of the Action Research programme. Liesbeth Bik belonged to the artistic team of Beyond from 2005 to 2007 and teaches at the Piet Zwart Institute in Rotterdam.

Tom van Gestel chairs the artistic team of Beyond and is the artistic leader of SKOR (the Foundation for Art in the Public Space) in Amsterdam.

Art historian **Lotte Haagsma** writes about art and architecture, often in relation to the physical and mental space in the public domain, where the two disciplines regularly meet in modern cities. She also works as an editor for ArchiNed, the website that documents the ups and downs of Dutch architecture from day to day.

Henriëtte Heezen is an art historian, editor and freelance publicist. She served for some time as external project leader, in which capacity she was involved *inter alia* in the implementation of the multi-year sculpture project *Roulette* by Manfred Pernice.

Paul O'Neill is a curator, writer and artist. As a researcher, he is attached to the programme 'Commissioning Contemporary Art with Situations' of the University of the West of England, Bristol. From this base he leads the international research project 'Locating the Producers'. He frequently publishes articles about the work of curating, and was one of the compilers of the anthology *Curating Subjects* (Amsterdam/London, 2007).

Domeniek Ruyters is editor-in-chief of Metropolis M, a bi-monthly journal of contemporary art, and the website www.metropolism.com, besides which he is on the staff of the daily newspaper *de Volkskrant*. He writes about a variety of subjects related to contemporary art for both Dutch and international publications, most recently about Alexander van Slobbe, the photography of Anuschka Blommers & Niels Schumm, and autonomous art in the creative city.

180

Artist **Fernando Sánchez Castillo** designed a contemporary monument for Leidsche Rijn Culture Park. He lives and works in Madrid, and was attached to the National Academy of Art in Amsterdam as a resident artist for a number of years. In 2004 his activities included taking part in the Biennale of São Paulo and the exhibition 'The Failure of Beauty/The Beauty of Failure' in Barcelona, and in 2008 he produced a major work for the international exhibition of sculpture 'Grandeur' in Park Sonsbeek, Arnhem.

Marjolein Sponselee is an art historian and frequently writes about art in the public space. She is editor-in-chief of *Lucasx*, a journal of art and design published in Utrecht, besides which she works as an editor and coordinator for a variety of art projects.

Artist **Barbara Visser** produced two new works for Beyond. She regularly exhibits in the Netherlands and abroad and teaches at a number of academies of art and design. In 2007 she received the David Roëll Prize and in 2008 she won the Dr A.H. Heineken Prize. Since the beginning of her career she has explored the precarious balance between registering and stage-managing, and frequently plays with the notions of original and copy, conventions and codes, perception and projection. She uses a variety of media, from photography, film and video to texts, printing and performance.

Cor Wijn is attached to Hylkema Consultants in Utrecht. His field is policymaking and project management across the entire spectrum of the arts and cultural heritage. Besides writing exploratory policy papers for public authorities and start-up documents for policy programmes, he also supervises construction projects. Cor Wijn served as programme manager for Beyond from 2003 to 2007.

Credits

1 Dennis Adams, *Stadium*, 2002, photograph by Onno Kummer

2 Dennis Adams, *Stadium*, 2002, photograph by Onno Kummer

3 N55, *LAND*, 2003, Terwijde, photograph by Ralph Kämena

4 N55, *LAND*, 2003, Terwijde, photograph by Ralph Kämena

5 N55, *LAND*, 2003, Terwijde, photograph by Ralph Kämena

6 Overview of 'Parasite Paradise', with on the left *Mobile Linear City*, 1991, Vito Acconci, photograph by Ralph Kämena

7 Inge Roseboom, Mark Weemen, *Bar Raketa*, 2001, photograph by Ralph Kämena

8 Wolfgang Winter & Berthold Hörbelt, *Lichtspielhaus*, 1998, photograph by Ralph Kämena

9 Maurer United Architects, *Boerenwereldkeuken* mobile restaurant, 2003, photograph by Ralph Kämena

10 Exilhäuser Architekten, *Zusatzraum*, 2000, photograph by Ralph Kämena

11 Atelier Van Lieshout, *Pioniersset* mobile farmhouse, 2000–2003, photograph by Ralph Kämena

12 Overview of 'Parasite Paradise', with *Boerenwereldkeuken* mobile restaurant, 2003 and *Viva el Monopatin*, 2003, photograph by Ralph Kämena

13 HAP, *Room with a View*, 2001, photograph by Ralph Kämena

14 Kevin van Braak, *Camping Flat*, 2003, photograph by Ralph Kämena

15 Maurer United Architects, *Viva el Monopatin*, 2003, photograph by Ralph Kämena

16 Daniel Milohnic & Dirk Paschke (in collaboration with Resonatorcoop), *The Parasol*, 2001–2004, Vleuterweide, with the new *tiki* parasols, photograph by Lex Rijkers

17 Daniel Milohnic & Dirk Paschke (in collaboration with Lex Rijkers and Steffi Harzbecher), *Mobile Shed Unit*, 2001, during 'Parasite Paradise' in 2003, photograph by Ralph Kämena

18 Daniel Milohnic & Dirk Paschke (in collaboration with Lex Rijkers and Steffi Harzbecher), *Mobile Shed Unit*, 2001, during 'Parasite Paradise' in 2003, photograph by Ralph Kämena

19 Shigeru Ban, *Paper Dome*, 2004, Parkwijk, photograph by Andrei Chernikov

20 Bik Van der Pol and Korteknie Stuhlmacher Architects, *Nomads in Residence/No. 19*, 2004, photograph by Jos van der Pol

21 Marjolijn Dijkman and Wolter Osterholt, *Refuse Dump*, 2004, Terwijde, photograph by Dijkman/Osterholt

22 Mark&Mark&Paul, *Dossier Dream House*, 2004, Terwijde, photograph by Mark&Mark&Paul

23 Apolonija Šušteršič, *Cinema/Studio*, 2004, in *Nomads in Residence/No. 19*, photograph by Apolonija Šušteršič

24 Apolonija Šušteršič, *Cinema/Studio*, 2004, in *Nomads in Residence/No. 19*, photograph by Apolonija Šušteršič

25 Jesús Bubu Negrón, *Brite Bike*, 2005, in *Nomads in Residence/No. 19*, photograph by Simon van Dommelen

26 Jesús Bubu Negrón, *Brite Bike*, 2005, in *Nomads in Residence/No. 19*, photograph by Simon van Dommelen

27 Silke Wagner and Sebastian Stöhrer, *Coöperatie Terwijde*, 2006, Terwijde, photograph by Bureau Beyond

28 Silke Wagner and Sebastian Stöhrer, *Coöperatie Terwijde*, 2006, Terwijde, photograph by Bureau Beyond

29 Team TCHM and Daphne de Bruin, *Vicky Vinex* episode no. 14

30 Coralie Vogelaar, Rhino #1, 'Locals Only'

31 The exhibition 'Parallel Universe: the makeable country', by Utrecht Centre for Visual Art (CBK) in 2008, photograph by Bob Negrijn

32 Stanley Brouwn (in collaboration with Bertus Mulder), *The Building*, 2005, photograph by Misha de Ridder

33 The exhibition 'Master Humphreys Clock' of the Curatorial Training Programme, Amsterdam (De Appel) in 2008, photograph by Andrei Chernikov

34 Guillaume Leblon, *Domestic Cliff*, 2005, photograph by Misha de Ridder

35 Tomas Saraceno, *Solar Flying Plaza – Lighter than Air – Art – Architecture*, 2005, photograph by Misha de Ridder

36 Erik van Lieshout, *Up!*, 2005, photograph by Misha de Ridder

37 Aernout Mik, *Zone*, 2002, courtesy of Galerie Carlier Gebauer, Berlin

38 Jakob Kolding, *Untitled*, 2005, photograph by Judith IJken

39 Quirine Racké and Helena Muskens, *Celebration*, 2005, courtesy of NPS Submarin, photograph by Misha de Ridder

40 Barbara Visser, *Twee Projecties, Two Projections*, 2005, photograph by Misha de Ridder

41 Manfred Pernice, *Roulette (round I)*, Koehoornplein, photograph by Misha de Ridder

42 Manfred Pernice, *Roulette (round III)*, Koehoornplein, photograph by Misha de Ridder

43 Manfred Pernice, *Roulette (round III)*, Koehoornplein, photograph by Misha de Ridder

44 Dominique Gonzalez-Foerster, *Sainte Bazeille*, 2006, Hoge Woerd, photograph by Misha de Ridder

45 Dominique Gonzalez-Foerster, *Sainte Bazeille*, 2006, Hoge Woerd, photograph by Misha de Ridder

46 Monika Sosnowska, model of *The House*, in collaboration with Bart Duvekot

47 Sean Snyder, design for *The House*

48 Barbara Visser, *Transformation House, Part II*, animation: Olivier Campagne

49 Marko Lulic, design for *A House in Leidsche Rijn*

50 Hans Aarsman and Erik Kessels, design for *Leidsche Rijn Castle, an International Safe House*

51 Atelier Van Lieshout, design for *Villa Sculptura, Leidsche Rijn*

52 Sophie Hope, *The Reserve* open-air museum, 15 July 2007, Castellum Hoge Woerd, photograph by Jeroen Wandemaker

53 Sophie Hope, *The Reserve* open-air museum, 15 July 2007, Castellum Hoge Woerd, photograph by Frits Brouwer

54 Maja von Hanno, *Meet you at the Mountains*, 2008, De Woerd, photograph by Misha de Ridder

55 Melle Smets, video stills from the workshop *Sjek je Plek*, 2008

56 Mathilde ter Heijne, objects submitted for the work *Out of sight, but not out of mind*, created in Leidsche Rijn Sculpture Park

57 Fernando Sánchez Castillo, design for *Barricade* in Leidsche Rijn Sculpture Park

58 Rob Voerman, design for a tower in Leidsche Rijn Sculpture Park

59 William Speakman, design for *Wood Chapel* in Leidsche Rijn Sculpture Park

60 Daniel Roth, design for *Anonymous monuments* in Leidsche Rijn Sculpture Park

61 Zilvinas Landzbergas, design for a pond with a fountain in Leidsche Rijn Sculpture Park

62 Lucas Lenglet, design for *Observatorium* in Leidsche Rijn Sculpture Park

63 Gelatin, design sketch for *Das Organ*, 2002

64 Sophie Hope, *The Reserve* open-air museum, 15 July 2007, Castellum Hoge Woerd, photograph by Frits Brouwer

65 Shigeru Ban, *Paper Dome*, 2004, Parkwijk, photograph by Andrei Chernikov

66 Monica Bonvicini, *Light my Fire*, 2005, Leidsche Rijn, photograph by Misha de Ridder

67 Manfred Pernice, *Roulette* (round V), Koehoornplein, photograph by Misha de Ridder

68 The exhibition 'House for Sale', in The Building, 2006, photograph by Johannes Schwartz

Organization

Beyond is a project of the department of Cultural Affairs of the Utrecht City Council with SKOR (Foundation for Art and Public Space) and Leidsche Rijn Project Agency Utrecht.

Beyond has a working budget of 8.5 million euro over 11 years. Of this around 3.5 million has been provided by Utrecht City Council. The remaining amount has been obtained through sponsoring and subsidies. Main sponsors are the Ministry of Housing, Spatial Planning, and the Environment (VROM) through the IPSV programme (Innovation Programme for Urban Renewal) and SKOR (Foundation for Art and Public Space). Other sponsors are K.F. Hein Foundation, Netherlands Foundation for Visual Arts, Design and Architecture (Fonds BKVB), the Prins Bernhard Cultuurfonds, Province of Utrecht, VSB Fonds and (formerly) D2-funding of the European Union. Real estate developers active in Leidsche Rijn like AM, Amvest, ASR Vastgoed, Ballast Nedam and Bouwfonds have sponsored the realization of the Sculpture Park Leidsche Rijn.

The realization of Beyond has been made possible through important contributions by:

Jan van Adrichem, Wendel ten Arve, Barbara van Beers, Liesbeth Bik, Harrie Bosch, Michiel Brouwer, Daphne de Bruin, Carlijn Diesfeldt, Monique Dirven, Mariette Dölle, Linde Dorenbosch, Petra Dreiskämper, Cees van Eijk, Tom van Gestel, Toon Gispen, Joost de Groot, Govert Grosfeld, Jan van Grunsven, Bart Guldemond, Henriëtte Heezen, Wendela Hubrecht, Nico Jansen, Felix Janssens, Jan Jessurun, Bernadette Klein Douwel, Jeroen de Leede, Walther Lenting, Wilfried Lentz, Mirjam Lode, Petra Meijjer, Souad Metalsi, Martin Mulder, Hans van Oort, Hans Ophuis, Carmela Petallar, Wouter van der Poel, Annemiek Rijckenberg, Emmy Rijstenbil, Trudie Timmerman, Theo Tegelaers, Ivo van Werkhoven, Yvonne Wesselink, Cor Wijn, Leen de Wit, Nathalie Zonnenberg, and all artists and architects.

Beyond wishes to thank:
Villa Zebra, Cultuur19, Stichting Bouwloods Utrecht, Zuwe Welzijn, Wijkbureau Leidsche Rijn, Informatiecentrum Leidsche Rijn, ABKV and the many collaborators of the services Maatschappelijke Ontwikkeling, Stadswerken and Stadsontwikkeling of the City of Utrecht.

Acknowledgements

This publication was made possible by the financial support of the city of Utrecht, the Netherlands Architecture Fund and SKOR

Gemeente Utrecht

Compiled and edited by
Monique Dirven
Tom van Gestel
Henriëtte Heezen, editor-in-chief
Cor Wijn
Nathalie Zonnenberg

Translators
Beverley Jackson
(texts Haagsma, Wijn, Visser)
Lynn George
(texts Projects, Sponselee, Van Gestel)
Jantien Black
(text Ruyters)
Mike Ritchie
(texts Projects, Scenario Beyond)

Illustration editors
Michiel Brouwer
Carlijn Diesfeldt
Henriëtte Heezen

Copy Editor
D'Laine Camp

Project coordination
Linda Schaefer
NAi Publishers, Rotterdam

Publisher
Eelco van Welie
NAi Publishers, Rotterdam

Graphic Design
TOTAL IDENTITY
Felix Janssens / Alexander Shoukas

Lithography and printing
Die Keure, Bruges

Paper
Arctic Volume White 115 grs

187

With special thanks to

Michiel Brouwer, Bernard Colenbrander, Carlijn Diesfeldt, Mariette Dölle, Peter Kuenzli, Liesbeth Melis, Martin Mulder, Wouter Vanstiphout and all of the authors and artists.

NAi Publishers is an internationally orientated publisher specialized in developing, producing and distributing books on architecture, visual arts and related disciplines.

www.naipublishers.nl

Available in North, South and Central America through D.A.P./Distributed Art Publishers Inc, 155 Sixth Avenue 2nd Floor, New York, NY 10013-1507

tel +1 212 627 1999
fax +1 212 627 9484
dap@dapinc.com

Available in the United Kingdom and Ireland through Art Data, 12 Bell Industrial Estate, 50 Cunnington Street, London W4 5HB

tel +44 208 747 1061
fax +44 208 742 2319
orders@artdata.co.uk

Printed and bound in Belgium

ISBN 978-90-5662-705-8